Oglethorpe's Dream
A Picture of Georgia

Oglethorpe's Dream
A Picture of Georgia

Photographs by
Diane Kirkland

Text by
David Bottoms

A project of
The Georgia Department of Industry, Trade & Tourism
The Georgia Humanities Council

The University of Georgia Press
Athens and London

© 2001 by The University of Georgia Press
Athens, Georgia 30602
The Georgia Humanities Council
Atlanta, Georgia 30303
and The Georgia Department of Industry, Trade & Tourism
Atlanta, Georgia 30303
"Oglethorpe's Dream" © 2001 by David Bottoms
Photographs by Diane Kirkland © 2001 by
The Georgia Department of Industry, Trade & Tourism
All rights reserved
Designed and typeset by Linda M. Patrick,
The Georgia Department of Industry, Trade & Tourism

The paper in this book meets the guidelines for permanence
and durability of the Committee on
Production Guidelines for Book Longevity of the
Council on Library Resources.

Printed in Hong Kong through Phoenix Offset
05 04 03 02 01 C 5 4 3 2 1

Library of Congress Cataloging-in-Publication Data
available upon request
2001035246
ISBN 0-8203-2343-8 (alk. paper)

British Library Cataloging-in-Publication Data available

FOREWORD

I have always loved Georgia. In fact, I have never even considered making any other place my home.

This state has grown and changed in so many ways during my lifetime, from the new skylines created by booming business to the new cultural activities emerging from our ever-changing population. But the one thing that always remains the same is the true beauty of this state and its people.

Once I became governor, I realized that we needed to create something through which we could share the uniqueness of Georgia with others around the country and the world. *Oglethorpe's Dream: A Picture of Georgia* does just that.

What pleases me most about this book is that it explores many of Georgia's hidden treasures—sights and sounds off the beaten path that even those who live in this state might not yet have experienced.

I want to thank the Georgia Department of Industry, Trade & Tourism, the Georgia Humanities Council, and the University of Georgia Press for all they have done to make this book possible. I especially want to thank Georgia's poet laureate, David Bottoms, and the book's photographer, Diane Kirkland, for creating the compelling words and pictures you will find throughout the following pages.

As you immerse yourself in *Oglethorpe's Dream*, I hope that you are as intrigued and impressed by the people and places here in Georgia as I have been my entire life.

Roy E. Barnes
Governor of Georgia

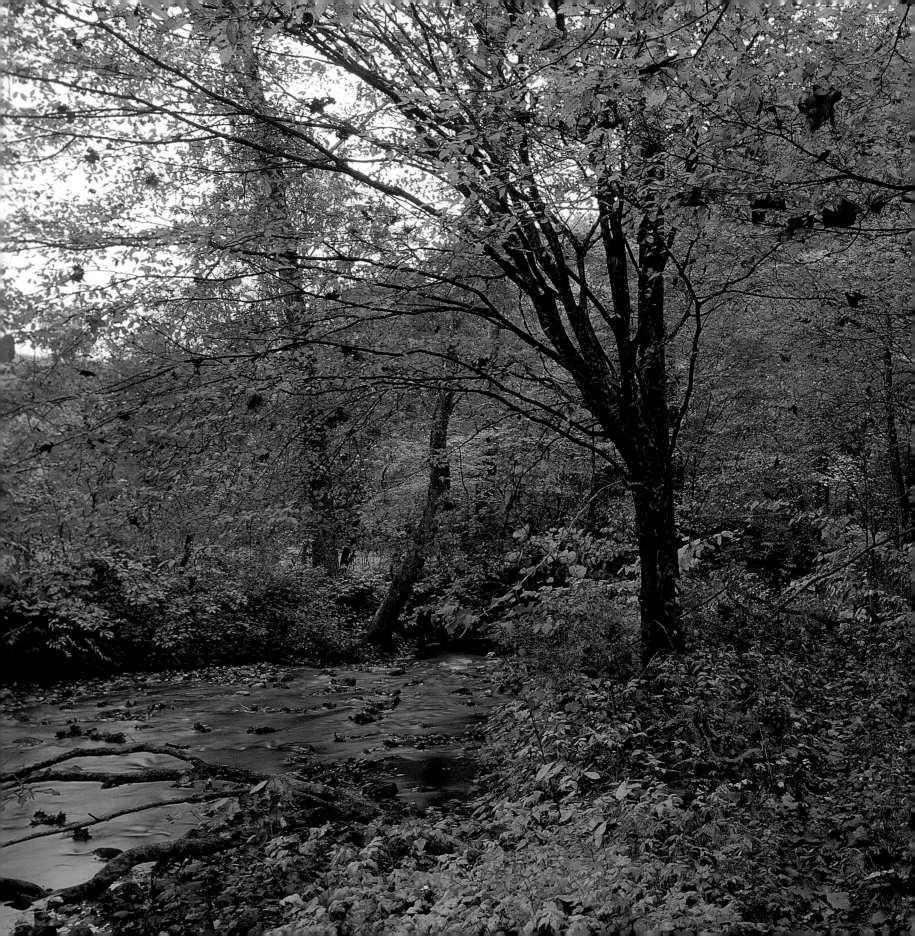

I. A Mission and a Place

[A]

Wherever you are
start with sunlight. Whatever gives itself over to sunlight is touched
and changed.
 Sometimes even the spirit of a place bathes
in it like a living thing—no, as *other* living things,
and in lucky moments
you can feel it, a fine grain in the air, a brush against your face
softer than the touch of a peacock's feather,
softer, yes, than the kiss of dust motes
in a lighted hallway,
the spirit of a place gathering itself
in a shaft of light, becoming palpable, becoming something
to grasp, something to step into, something
on which to be swept away.
 The receptive heart grabs on,
holds on—and quick as a wish you're airborne, flung
like Elijah in a whirlwind of flame
while the grainy light
at your fingertips crystallizes into a ridge of blue-green pine tops,
into a ruffled quilt of oak, poplar, hickory,
and water, yes,
 a dark river spilling into a bright lake,
and far off, a few fields scratched with roads.

—————

The Chattahoochee National Forest in Rabun County

Hold on against the swirl, the overwhelming sweep of landscape.

Here you are now, coming back to yourself,
coming back to yourself in Georgia.
 Under one foot, the tin-foil sparkle
of water—Lake Burton, Lake Rabun,
Chatuge, Notley—under the other,
 the crest of the Blue Ridge . . .

Move around and let the green rise of mountains turn under you,
the clearings and tree-splotched pastures
speckled with cattle,
 with chicken houses, barns, trailers, houses,
with highways crisscrossing like the silver trails
of slugs. And the great clots, also, of brick
and concrete—
 Blairsville, Clarksville, Hiawassee, Clayton—
from this distance all much the same,
 and yet already unique.
Move around, sure, to find an entrance.

Isn't that what you always hoped for,
to find a place
 and yourself in that place?

Why not try a river? A river, at least, is going someplace.
A river has a mission.

Look, just off the north bank, a clearing and a red trail narrowing
into the woods.
 A movement in the brush . . .

Something like hope about the late morning light,
the way it sifts through the needles and finger-branches, draping itself
in slices across the road, the way it glazes those trousers
and Sunday shoes, the skirts
of Sunday dresses.
 Coming down the hill with them, coming
down the ridge where the dirt road chokes to a brushy trail,
 you blink out
the sun, and the trees open onto sky and water.

A blade of wing, deeply rusted, glides far off over the blue wall of pines—
banks and glides.
 The sky beyond is bluer still, the river
underneath, the red of dried blood.

That blood is the blood of the Lamb.
Or so the words say
falling off their tongues, the thirty or forty you follow to the water,
the fountain someone is about to be washed in.

Shiloh Baptist, Macedonia, Soul Harbor, Philadelphia?
Who are they, scattering
 their four-part drone along the river's edge?
When the Bridegroom cometh will your robes be white?
And two men kick off their shoes and wade out
toward the long branches of an oak
 sagging over the far bank.

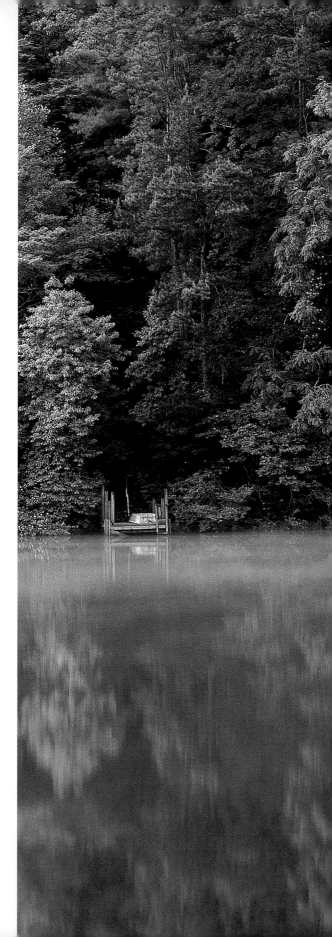

A fishing cork dangles from the lowest branch.
Knee-deep, thigh-deep, waist-deep,

and they turn to face the singing.
The sun finds a cloud, and a shadow finds the river,

and scrutinizing the fields, unconcerned,
as though this cleansing has always gone on here,
and always will,

the hawk banks low over a swell of white oak.

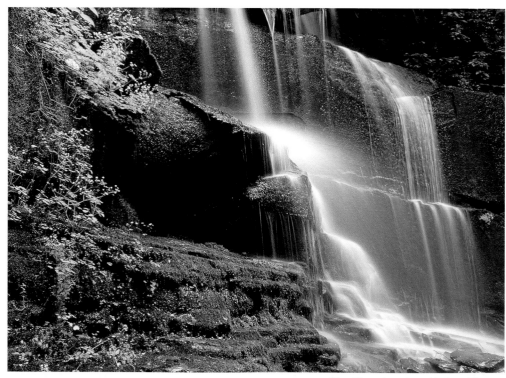

The Chattahoochee National Forest

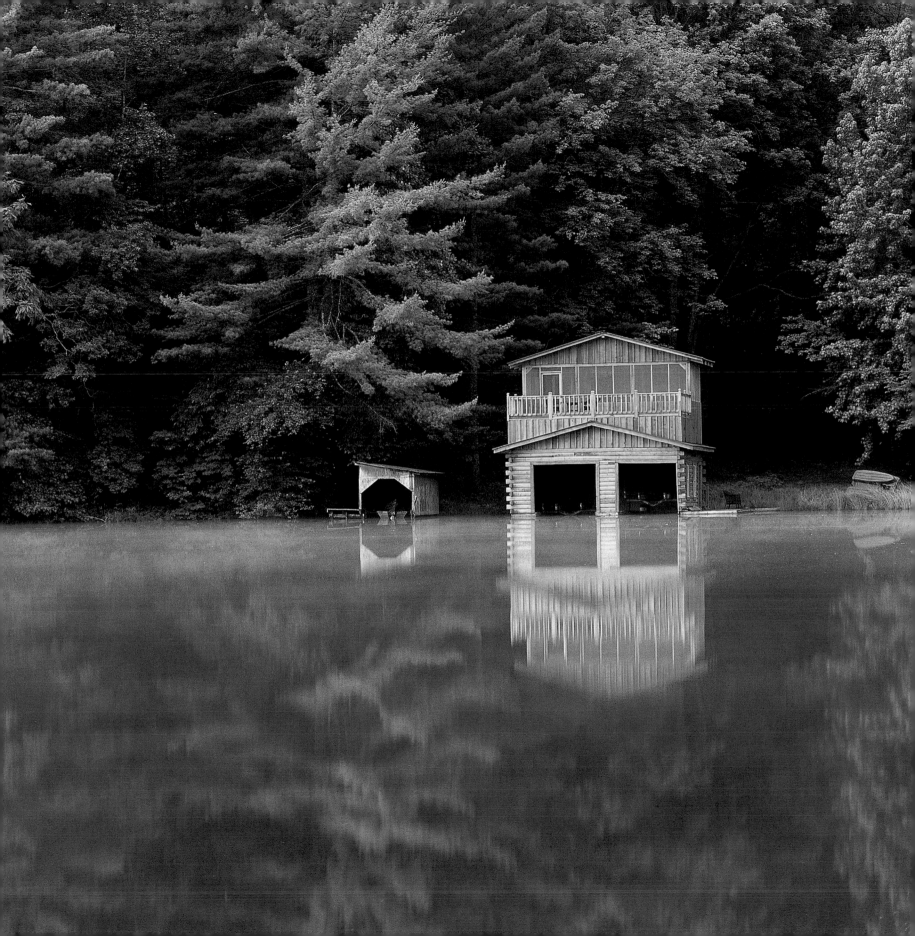

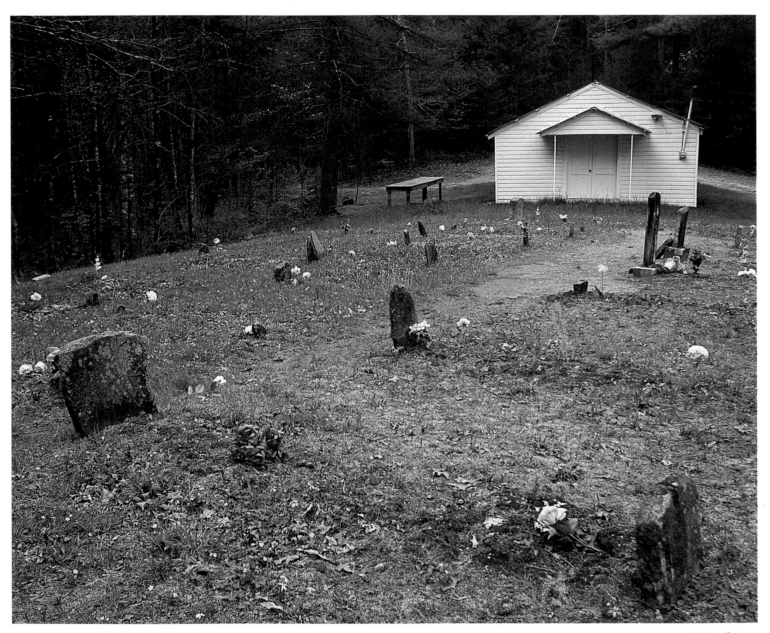

Union County

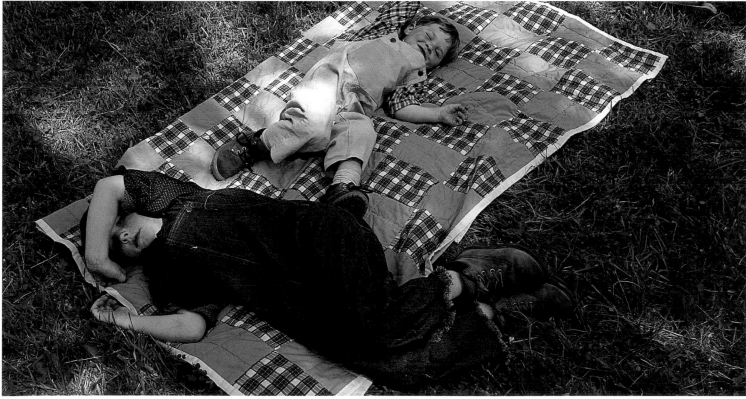

The Foxfire Community Picnic in Rabun County

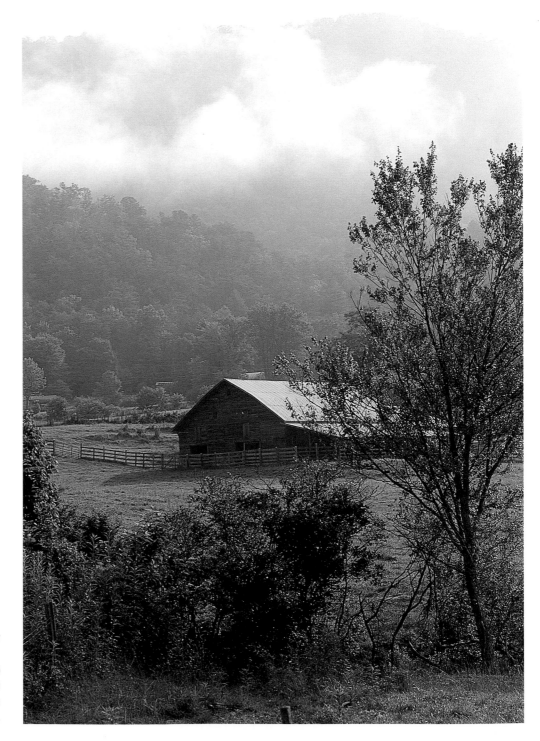

Towns County

(facing page)
101-year-old Ross Brown plays his
well-worn fiddle at the Foxfire
Community Picnic.

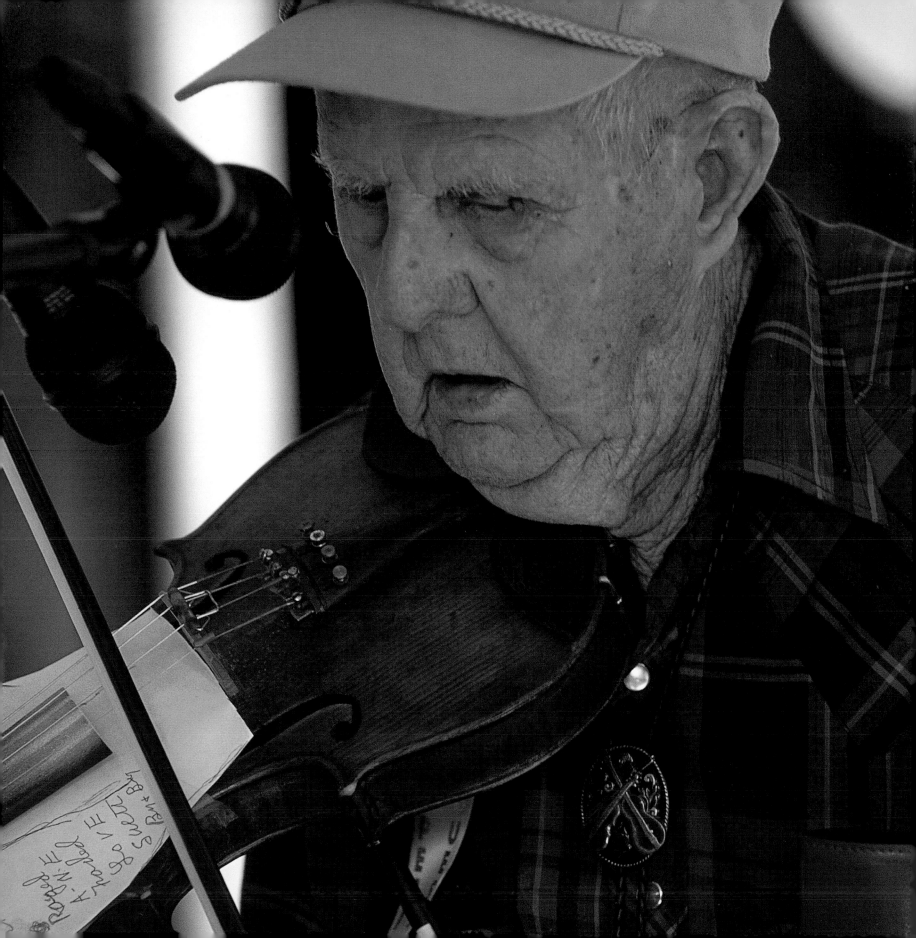

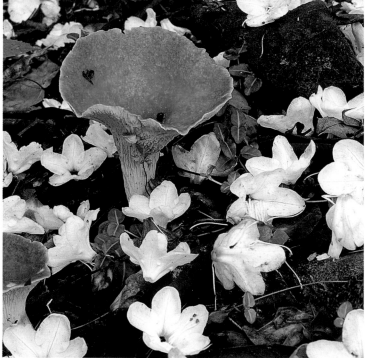

The Chattahoochee National Forest

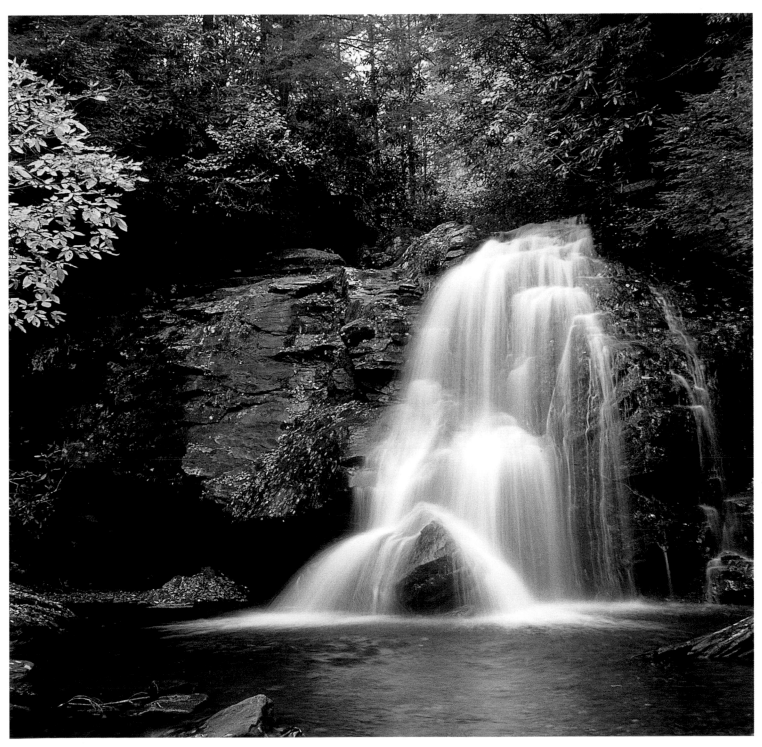

Raven Cliff Falls in White County

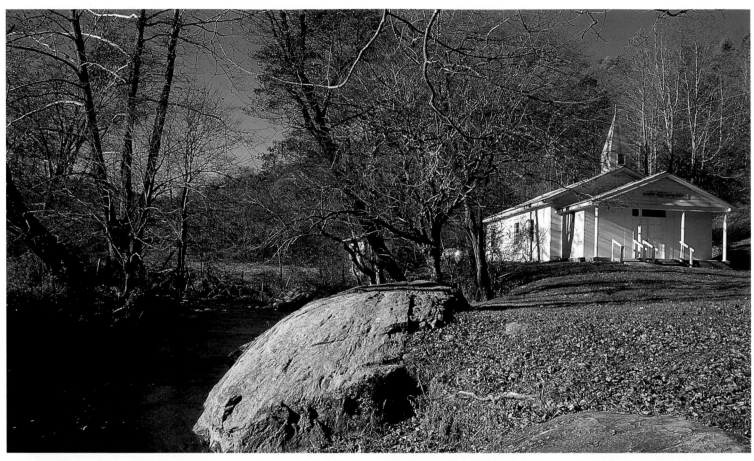

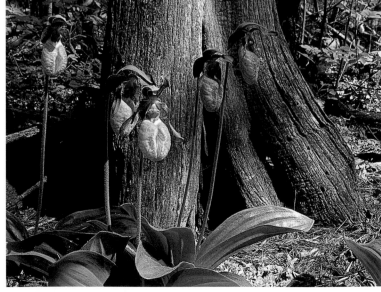

Fannin County

[B]

Downriver a ways,
ten miles, twelve, where the river wallows and deepens in a bend,
a small boat is tied against the bank,

a beat-up johnboat tipsy with a woman
and a boy. Home in,
yes, a little closer—an old woman under a wobbly hat, her hard gaze
running upriver where the thin line, almost invisible,
vanishes into the water.
Her mind runs with it, with the blue catfish along the deep bottom
where the big lead weights
 anchor their wads of night crawlers.

All morning she's baited both lines, and waited,
while the boy leaned back on his cushion,
 fingering a black flint.
Arrowhead, he thinks, though *maybe* is all she offers.

Maybe, yes, but enough to set his mind picturing . . .
narrow road opening on a log town.
New Echota, of course. Town square and Council House,
print shop, courthouse, tavern.
Sequoyah is there, also, with his tablet of talking leaves,
his alphabet of syllables,
 then those long herds
of driven people, the woods alive
with their grief. The picture that comes to him again and again—
bloody feet, bloody feet . . .

———

Or go there yourself, it's only a thought away,
what's left, that is. Just off Georgia 225, a few miles east of Calhoun.

Or say, like me, you take your small daughter to wander around
the rebuilt farmstead—
 chinked log house with roofed porch,
barn, smokehouse, corn crib. *So what about the Cherokees?*
You walk past the ball field,
the Council House,
 and tell her what you know. Not much,
not enough to quiet the ghosts passing along
the New Town Road.

Water oaks trembling around the courthouse,
their leaves like a strange language . . .
 Complaint? Indictment?
Who knows? But on a bench in the courthouse, you explain yourself
as best you can,
 then vanquish your eloquence
in the James Vann Tavern. *So what about the Cherokees?*
Hard to explain to a child.

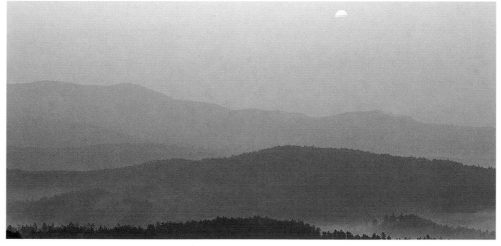

The Cohutta Wilderness Area

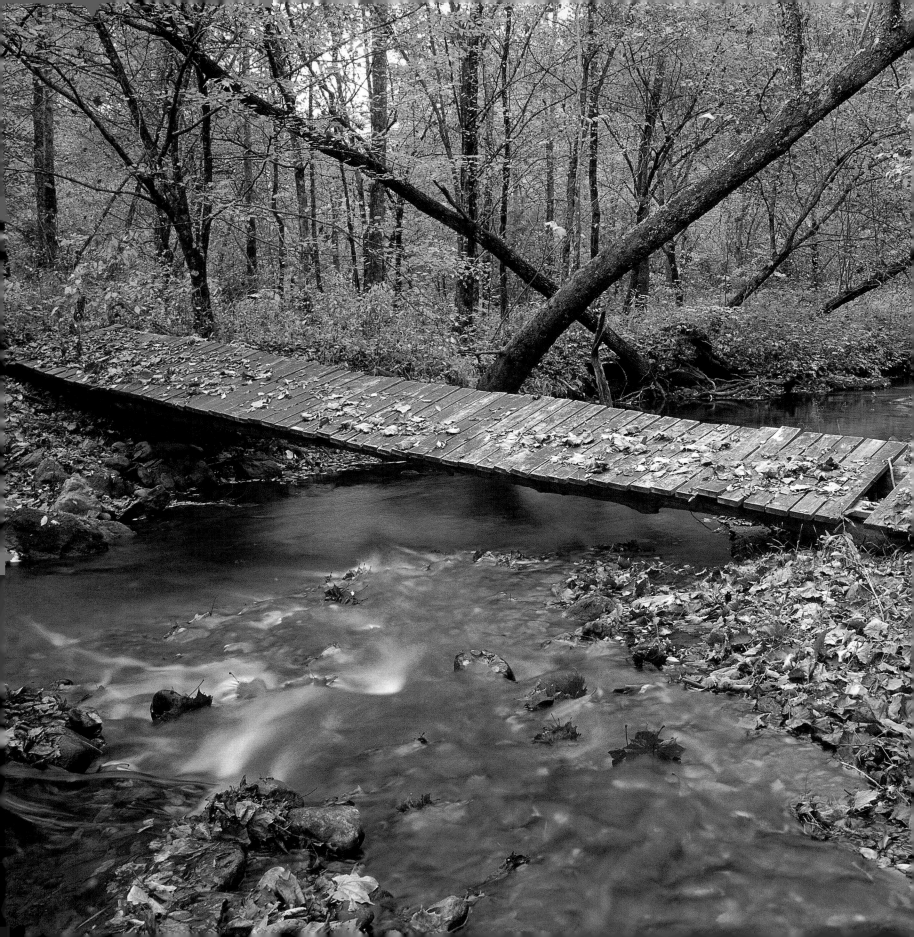

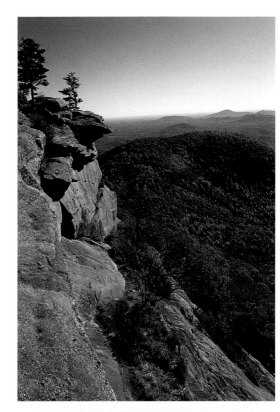

(far left)
The Hambidge Center in Rabun County

(left)
Mt. Yonah in White County

(below)
Tallulah Gorge State Park

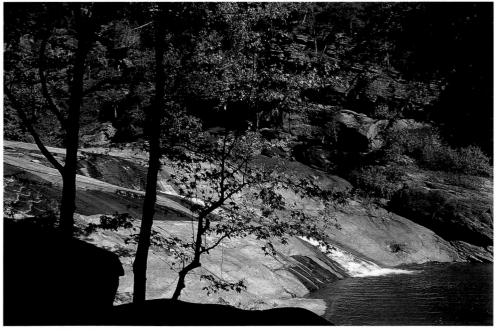

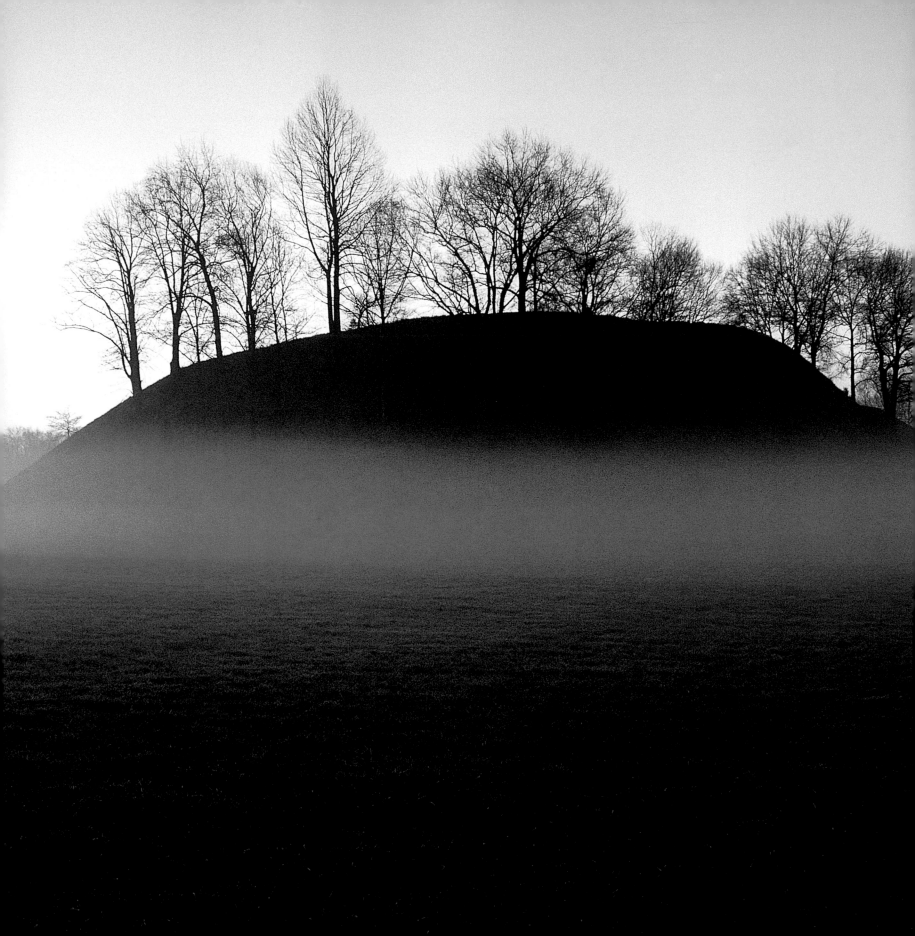

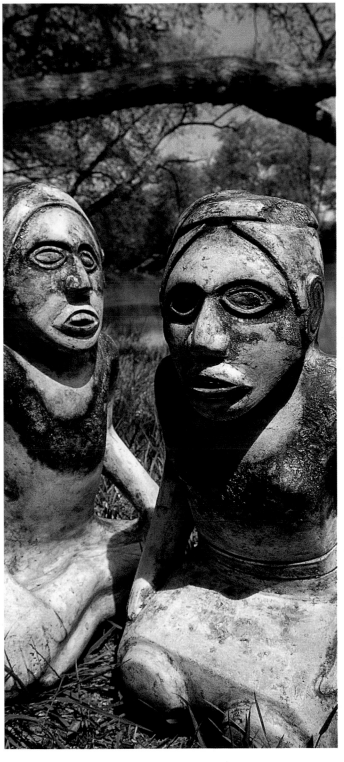

(facing page)
The Etowah Indian Mounds State Historic Site was a political and ceremonial center for Native Americans between 1000 and 1550 A.D.

(above)
Sequoyah single-handedly developed the Cherokee syllabary over the course of twelve years. In 1828 a Cherokee-language newspaper began publication in New Echota, the capital of the Cherokee Nation.

(right)
These marble effigy figures, found near the bottom of one of the Etowah burial mounds, are thought to have been protectors of the dead.

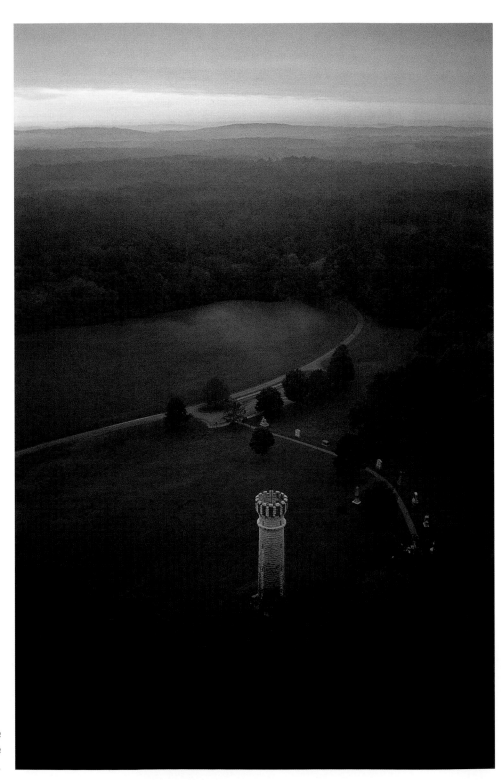

Chickamauga National Military Park, site of the second bloodiest battle of the Civil War, is the oldest and largest Civil War park in the country.

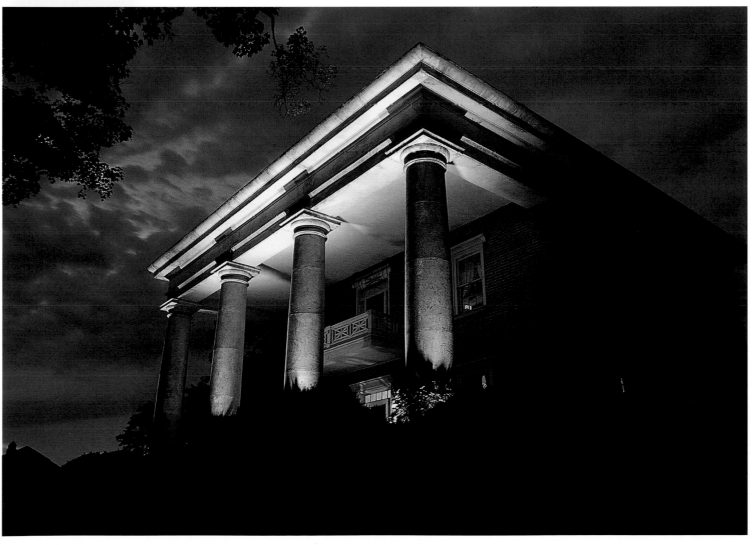

The Gordon-Lee Mansion (now a bed and breakfast) served as the Union Army hospital during the Battle of Chickamauga.

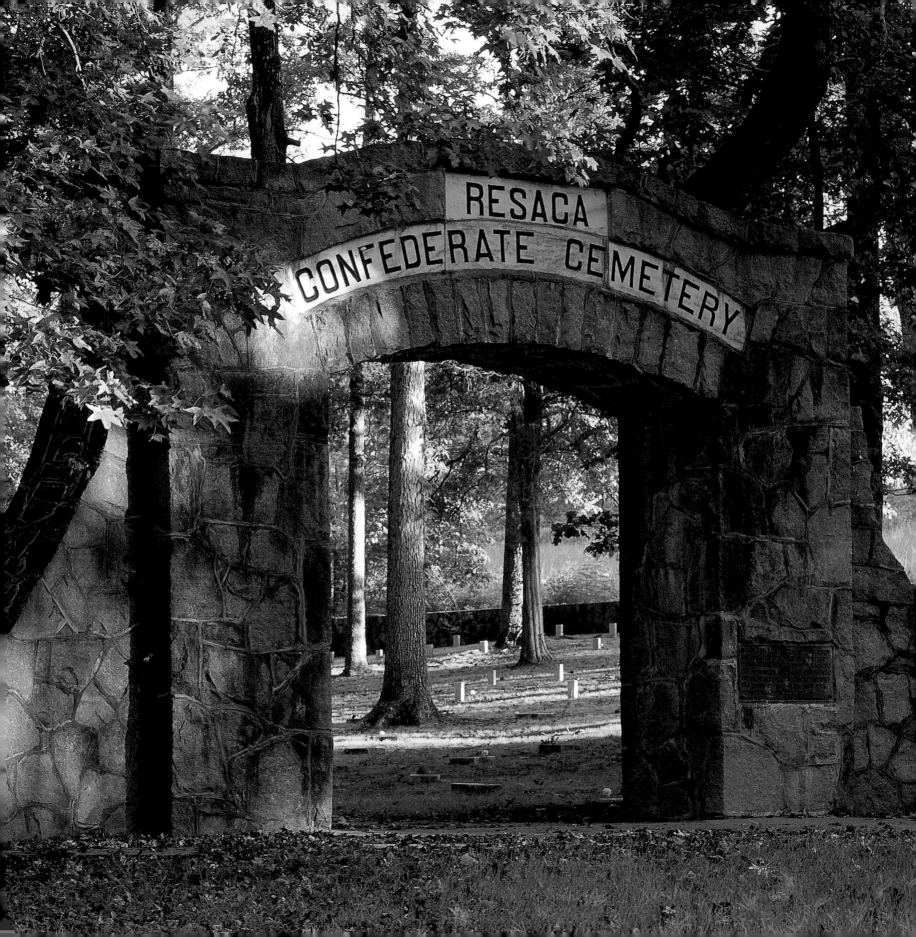

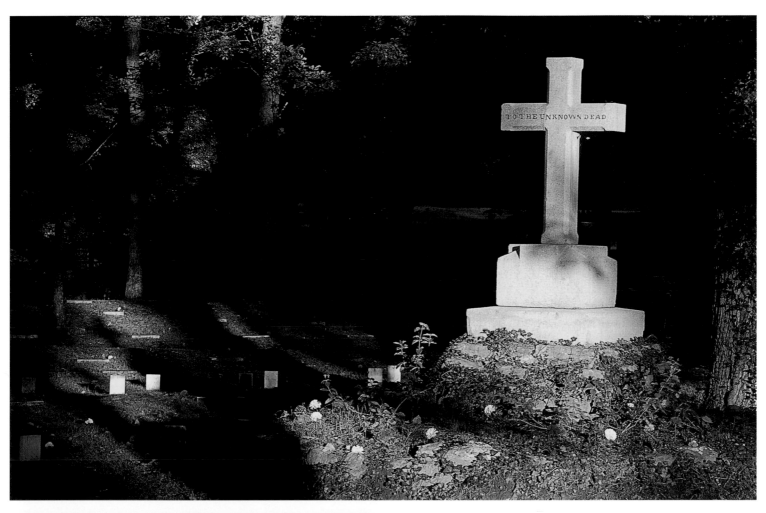

Mary Green gathered and interred the bones of the Confederate dead left lying on her family farm after the Battle of Resaca, establishing the oldest Confederate military burial ground in the South.

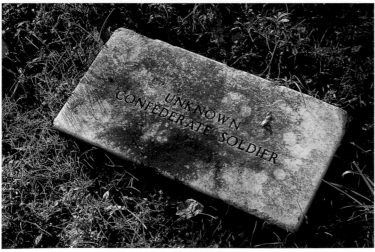

[C]

Consider, though, the ring on your finger,
 the hoop in your ear,
the crown on your tooth . . .

A few miles south of Dahlonega,
five miles, six, the *Auraria Church of Almighty God* hangs its sign
under a giant oak . . .
 Now think yourself a little farther.
Don't blink.

Pull up here on the porch of Woody's Store . . .
Nobody around,
nobody around for a while, and you don't need to try the knob
to know the doors are locked.
 Old white bench drooping
under a barred window, two Coke machines rusting
in a corner,
 a thermometer flaking paint—*say Pepsi please!*—
not much else but board-creak and wind, and far up the highway
a log truck shifting gears.

Next door the Graham Hotel sags into itself, the tin roof crumpled
into the second floor, which is crumpled
into the first,
 the whole thing propped against two trees.
Not even fit for a self-respecting ghost,
though this was the place, Auraria,
or part of it, the town that rumbled up from nothing
into a gold rush. 1828, yes, and Benjamin Parks,
hunting deer, kicks
over that famous rock,
 yellow as egg yolk . . .

Jack's River Bridge
in Murray County

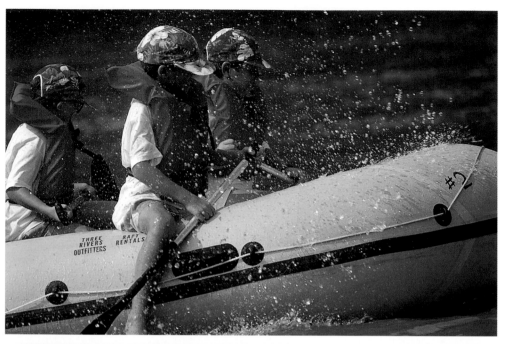

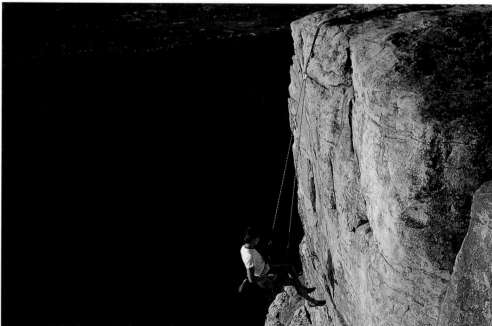

Lookout Mountain in Dade County

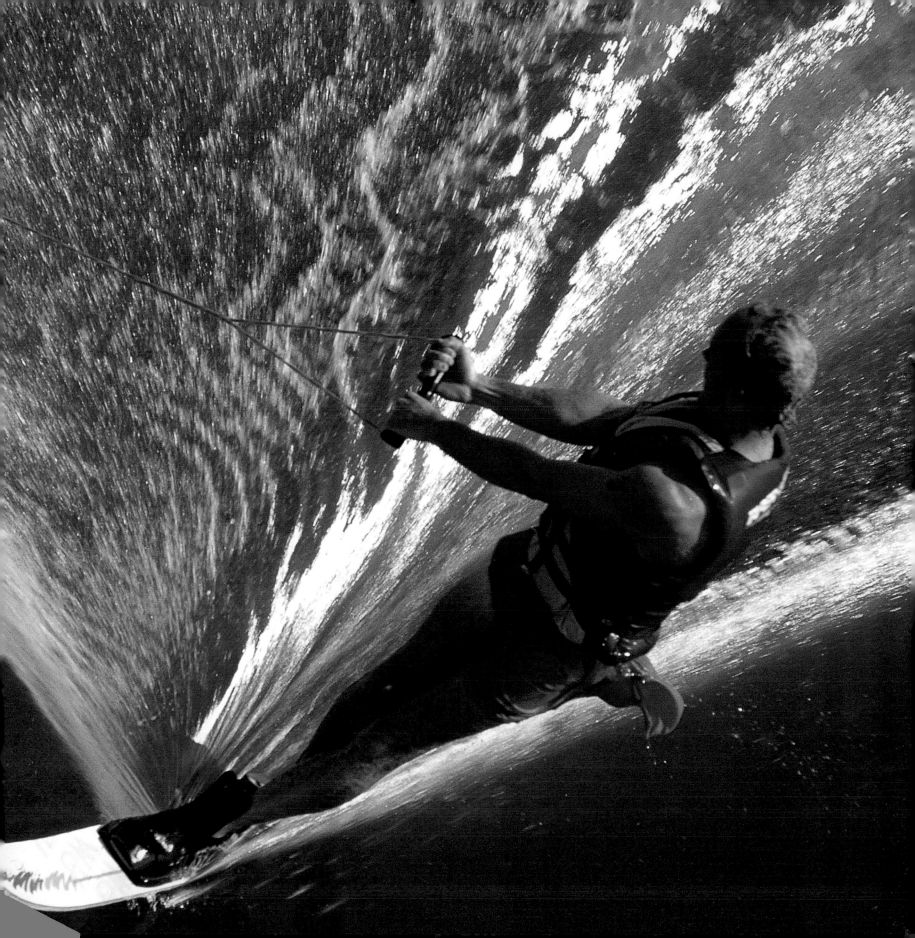

(below & right)
Winter scenes from the
North Georgia Mountains

(facing page, above)
Unicoi State Park in White County

(facing page, below)
Lake Rabun in Rabun County

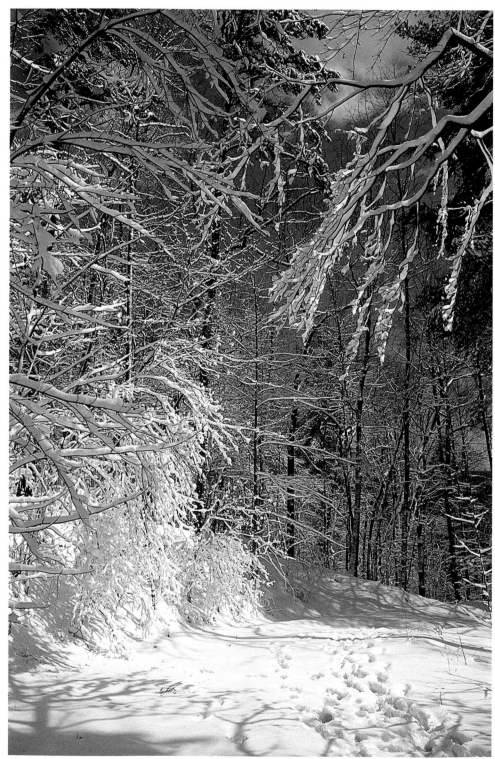

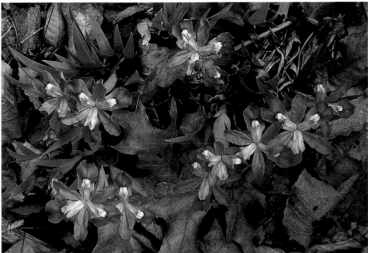

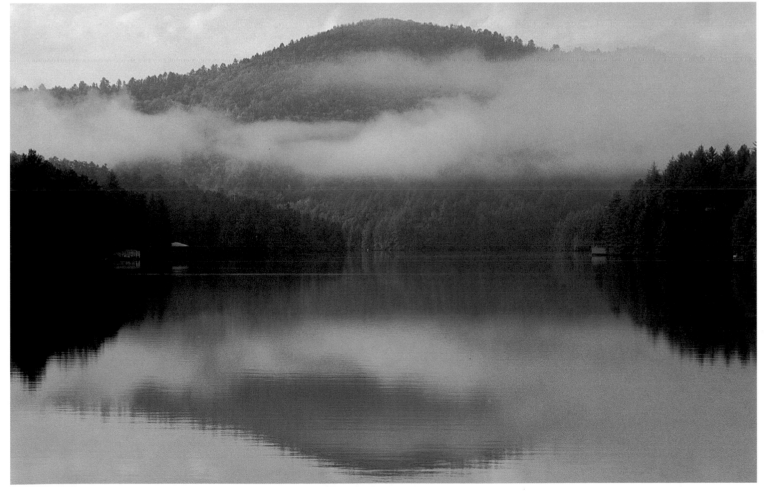

[D]

In a valley of the Blue Ridge, a black bear crosses a logging road.

Sunlight falls in streaks through the branches
and stripes its back and haunches.
 The sunlight streaks the red road
and a fallen pine.

A crow skirts the pine tops, flaps across a clearing.

The bear hears the crow caw across the creek,
a familiar sound the sky makes.

He tilts his head and pauses, but doesn't turn from his purpose,
which is now a stand of berries
 fattening along the creek.

Everything here has a mission.

You may never see this, but it is happening here without you.

But here's something to eye,
stretched out along the Coosawattee, like Satan's crooked walking stick.

Push through the brush
 and take a closer look—
fat spade head sunning on the rocks,
 slit gold eyes glazed in the sun,
oblivious to time and those rusty hourglasses
spilling down his back.

A native here, yes . . .

unvanquished, who holds in his jaw a taste of God's wrath.

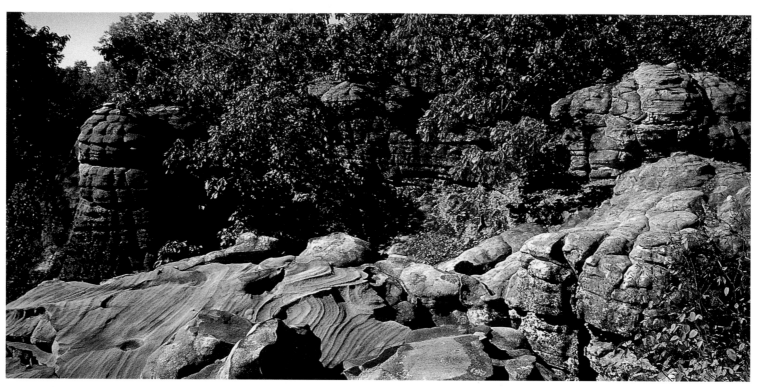

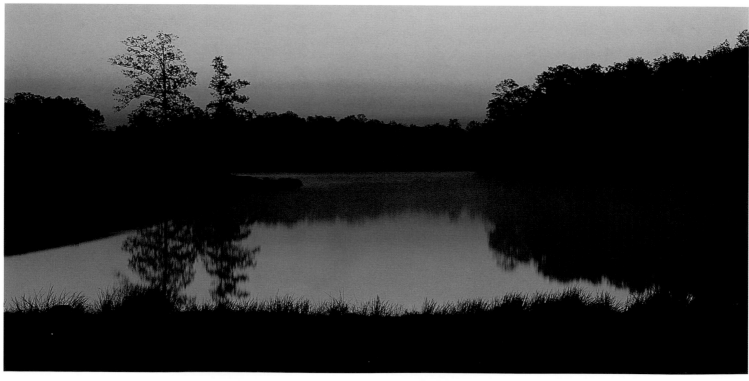

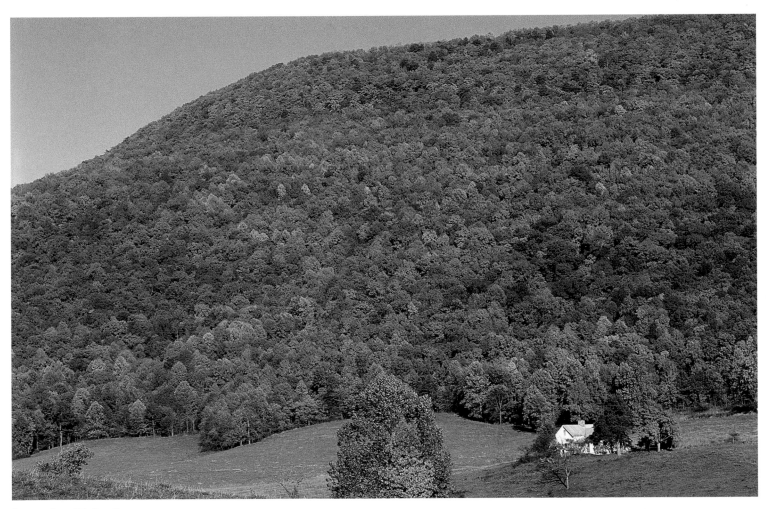

Scenes from Walker County

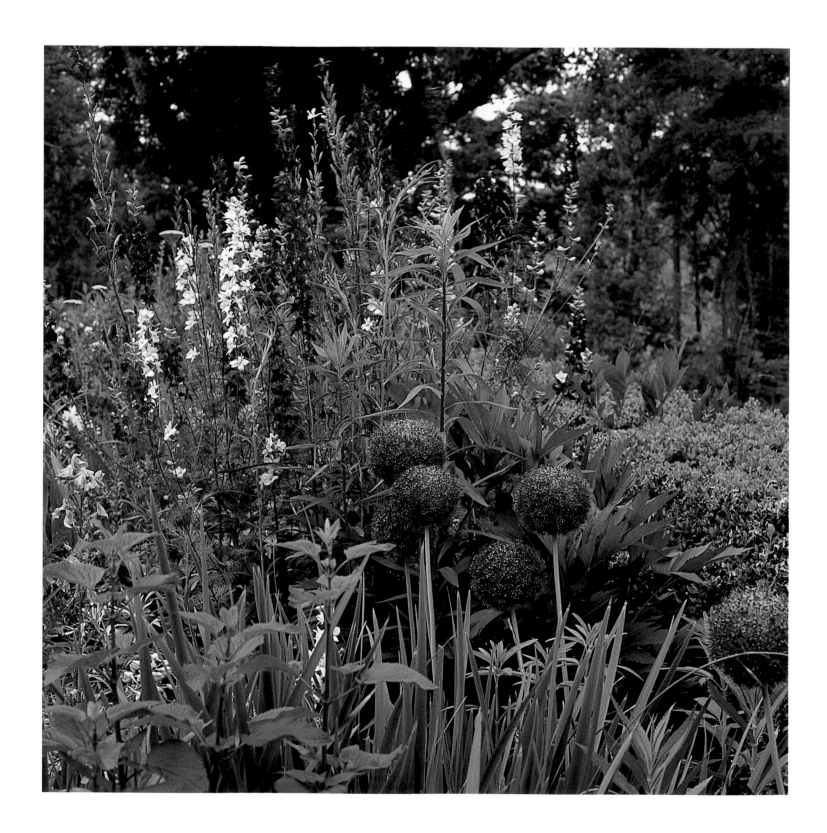

Barnsley Gardens in Bartow County

[E]

Another kind, not far off, slightly west.

Think Summerville, then a mile or two north—the narrow road
to Paradise Gardens. Howard Finster's Paradise Gardens.

Walk through the gate that says *GOD*,
and there it is—
a red-speckled serpent writhing on the wall of Paradise Cottage.
Its tongue points to a path,

and in Paradise every path is a good one,
all laid out in rainbow mosaics . . .
 Serpent Mountain, Hubcap Mountain,
the dark corridors of the World Folk Art Church,
the Garden Chapel with its unlikely spire
and balconies. In the Meditation Building the red angel hovering
over the white coffin
can tell you what to ponder.

Angels aplenty in these three acres, and serpents, and everywhere
you turn a prophecy . . .
 But be ye doers of the word
and not hearers only deceiving your own selves . . .

And it occurs to you, yes, the artist is a doer.

You too might be a doer.

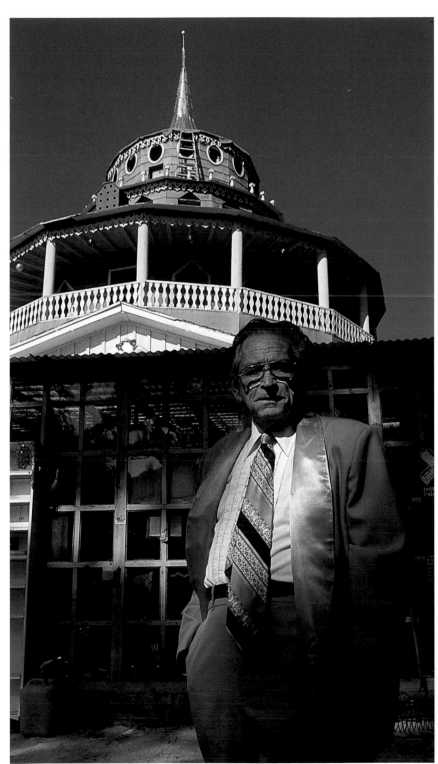

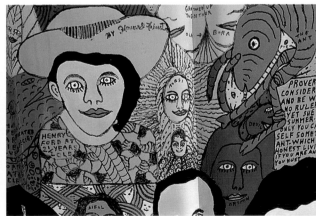

Self-taught visionary artist Howard Finster

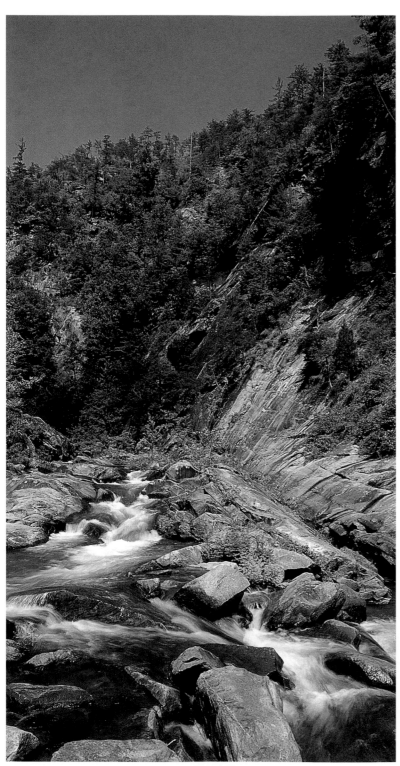

Scenes from Tallulah Gorge State Park

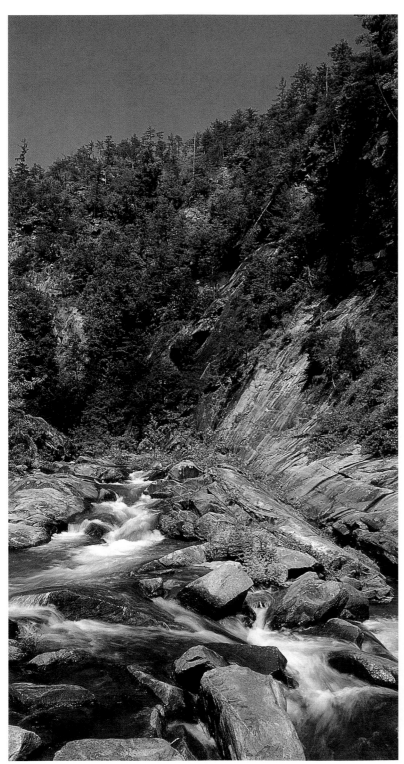

Scenes from Tallulah Gorge State Park

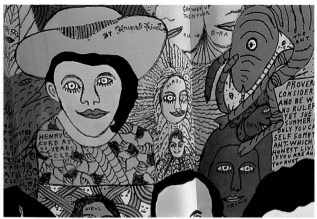

Self-taught visionary artist Howard Finster

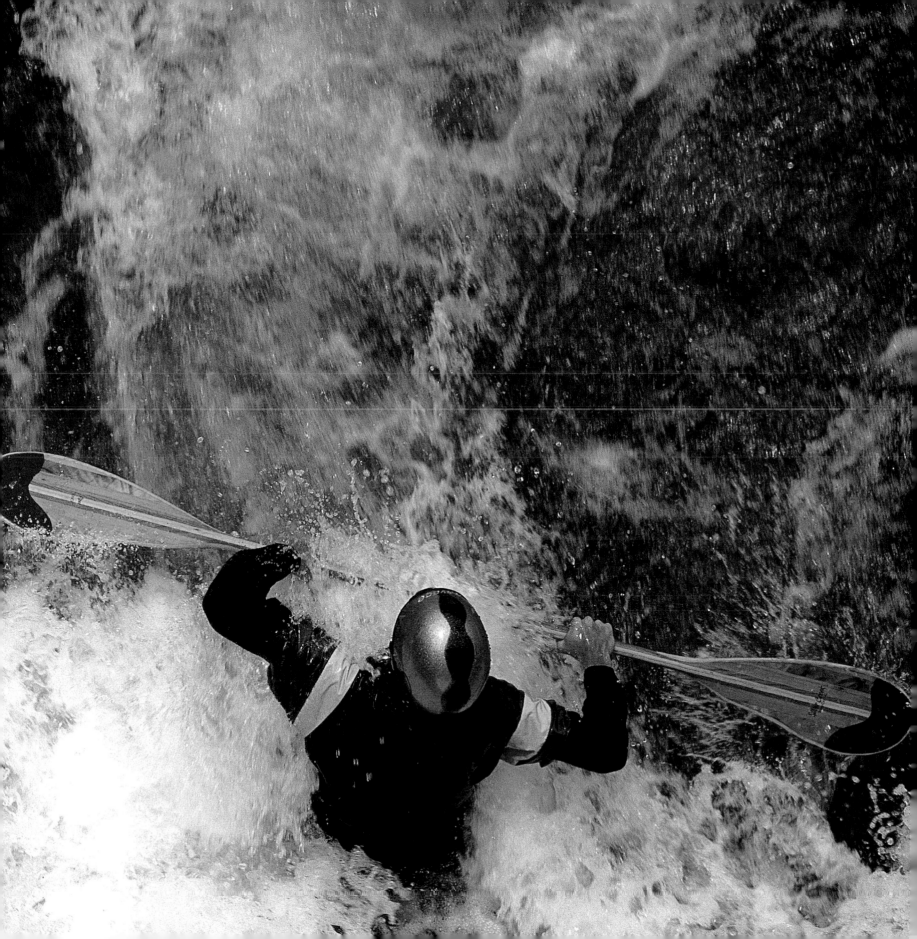

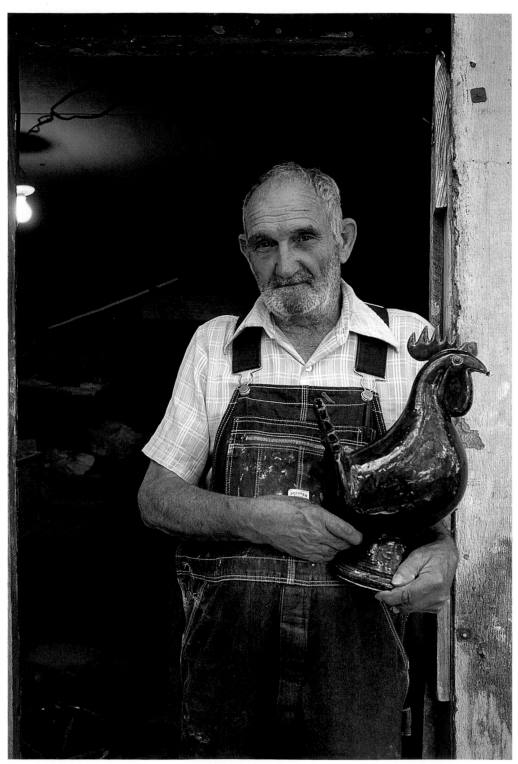

(left)
Folk pottery collectors prize the blue roosters
made by Edwin Meaders (Cleveland).

(facing page, above)
The Loudermilk Boarding House Museum
(Cornelia) is the home of artist Joni Mabe's
"Everything Elvis" collection.

(facing page, below & right)
Self-taught artist R. A. Miller (Gainesville)
shares his work with his grandson.

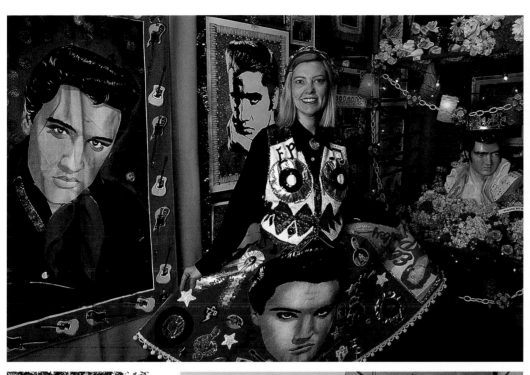

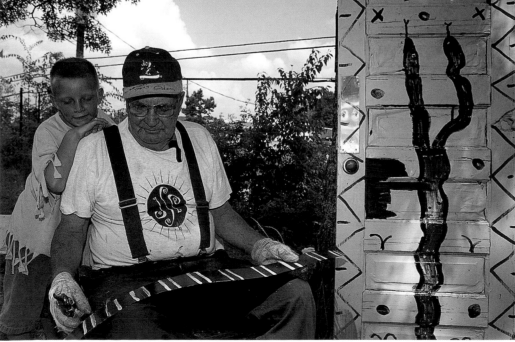

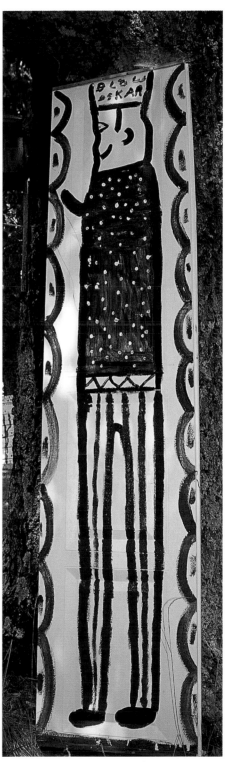

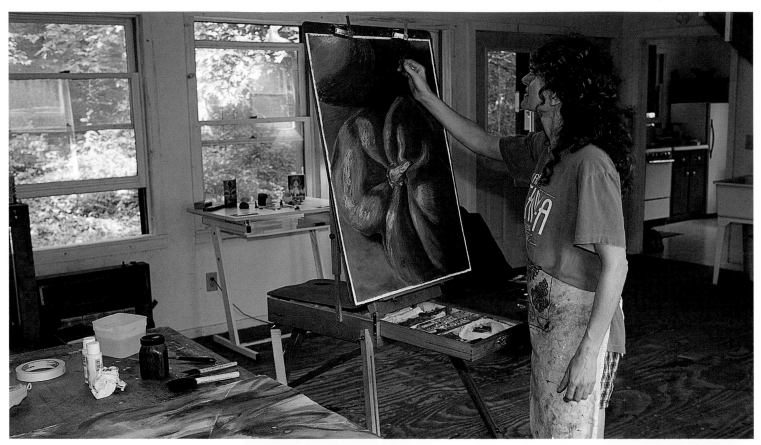

Listed on the National Register of Historic Places, Rabun County's Hambidge Center offers an artist-in-residence program that has hosted artists such as Anna Hamer.

(facing page)
Scene in White County

[F]

Each morning the doe brings her fawn to the waterfall.

In the first light sifting like clouds through shadows of trunk and leaf,
she brings her fawn
 to the edge of the pool.

As she listens for noise above the quiet noise of water,
 her fawn drinks.

Have you ever seen the way water
tumbling over rocks
 shatters into a white light?

Each morning
the doe and the fawn watch these spirits rise above the river.

———

From pine shadow and rail fence,
the raccoon watches the pasture ruffle its blanket of grass.

The tall grass wrinkles the long shadows of cattle,
and the raccoon, eager for nightfall,
fears her own shadow.
 She noses the slope and swell of the pasture,
the overwhelming fragrance from the yard beyond.

Inside the house a woman rocks in a chair by the window.
She looks up from her sewing
 and watches the pasture.

The shadows off the hill point the way to her window.

Her husband is gone, her son married,
and she has learned to sit still
and wait on the world,
 which even now comes calling occasionally
in all its disguise, and mystery,
and joy,
when she remembers to leave the lid off the garbage.

———

The woman rocking by the window
stitches into her quilt the rag-doll faces of children.

Twenty-one faces now, and she has given each a name.

She glances at the jugs on her kitchen cabinet,
the clay faces
 rigid in their blue-green gaze, and wonders
if they've been given names.

Sometimes they seem to her the faces of a lost people
risen out of the earth.

She knows the man who made them.
The smoke from his kiln leaves a gray wash over the hills.

She thinks about his hands and about her own hands.

The world is always becoming
something new, always taking on a fresh face.

———

That smoke rising at Mossy Creek . . .

This old shack, that's right, old man Meaders' jug shop,
I know it doesn't look like much.

Gaze at this jug, though,
and it gazes back. *One face shelved among his many brothers,*
the pig-face, the devil-face, the moon-face . . . sure,
but the face that chooses you in the crowd, catches your glance
and refuses to glance away.

Enough light sifting through the clay-streaked windows
to take the shop in,
but hard now to turn to the deep-glazed vases draped with snakes
and grape clusters, to the churns, to the fat-bellied roosters
crowing above platters,

these are the eyes that were burned for you,
the eyes you can't turn away from. In the ash-green mirror
of that absurd face
 your eyes
swimming in his gouged sockets, your cleft on his chin,
your lips floating over his tongue . . .

 ———

The artist is a doer, yes.

And the preacher waist deep in water, the maker of town squares
and council houses.

And the bear approaching the berry stand,
 the hawk circling endlessly
the meadow of blue flowers, the raccoon crossing the pasture,
the copperhead on his rock,
 the deer under the waterfall.

The doer has a mission
and a place. You too might be a doer.

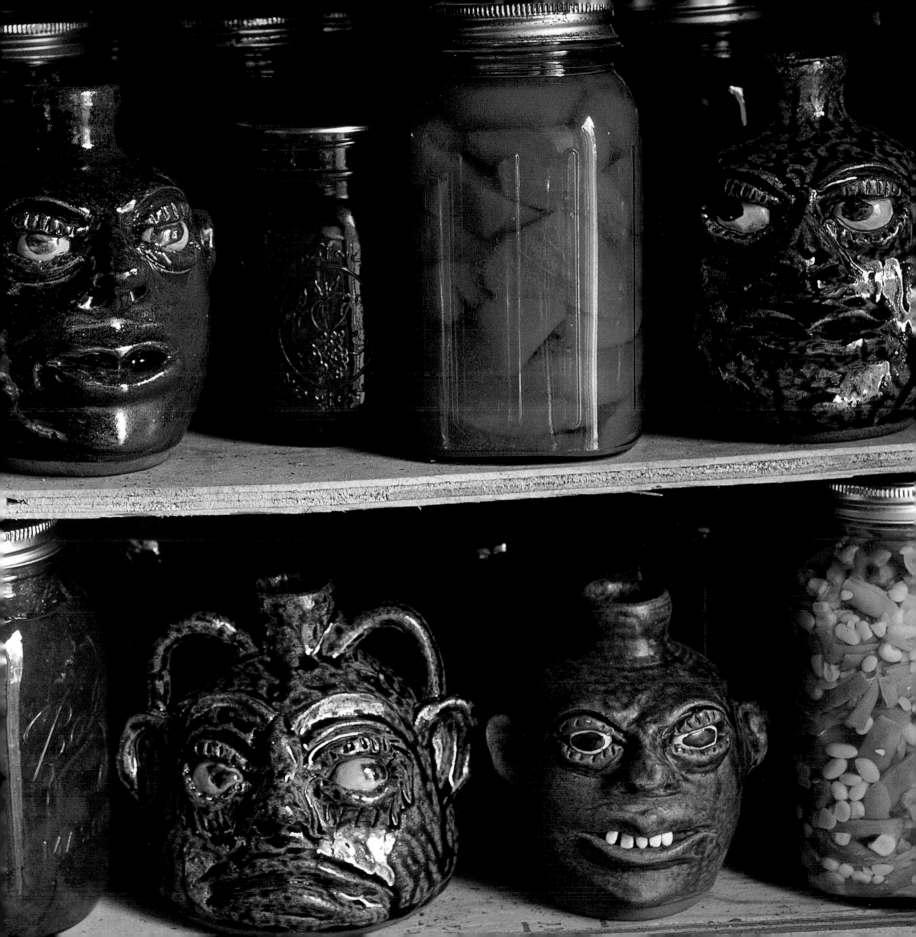

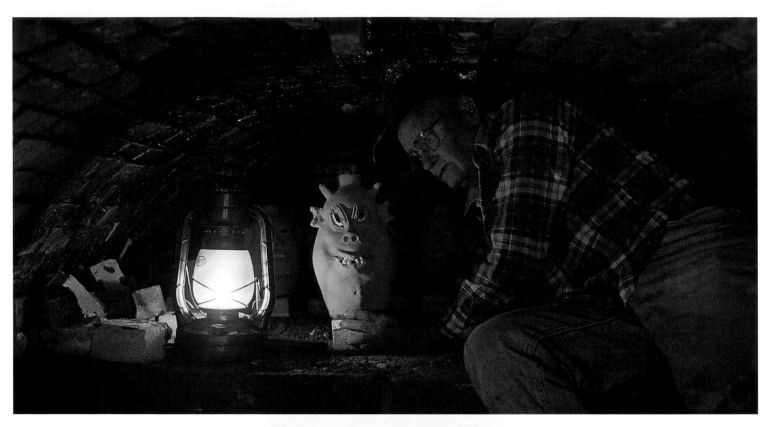

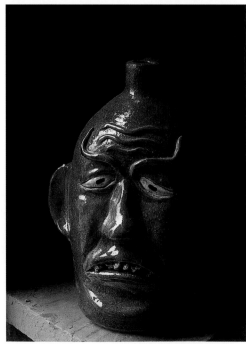

(above & left)
Cleater Meaders (Cleveland) continues his family's hundred-year-old tradition of folk pottery.

(facing page, left)
The annual "Turning & Burning Pottery Festival" celebrates six generations of the Hewell family folk potters.

(facing page, right)
Dahlonega's "Bear on the Square Mountain Festival" features bluegrass and old-time folk music concerts, jam sessions, and workshops.

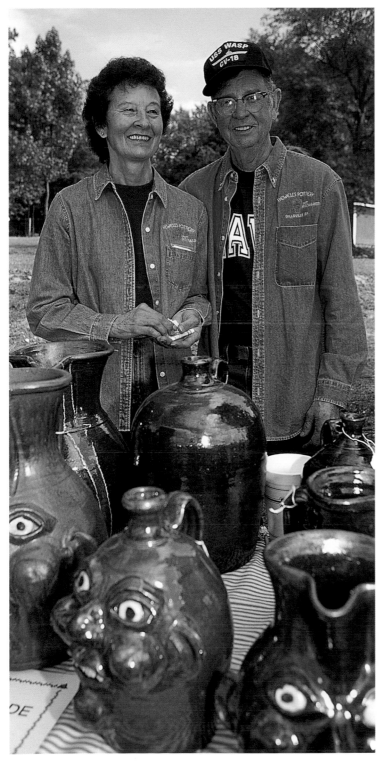

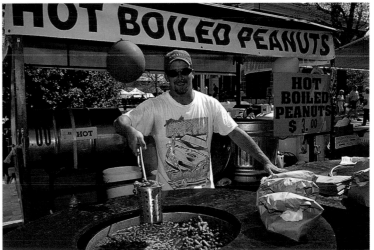
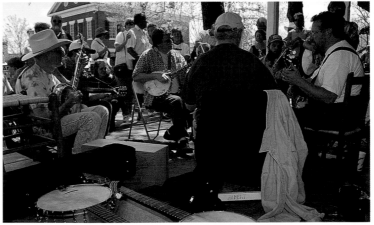

Berry College, founded in 1902 as a school for rural children, continues today as an unusually beautiful environment for learning with English Gothic–style classrooms in a natural setting.

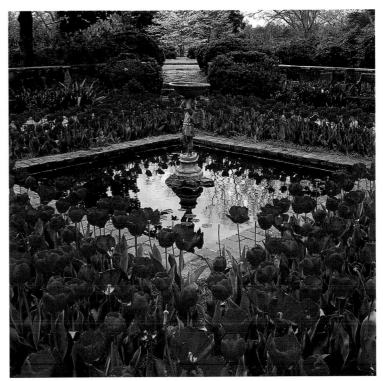

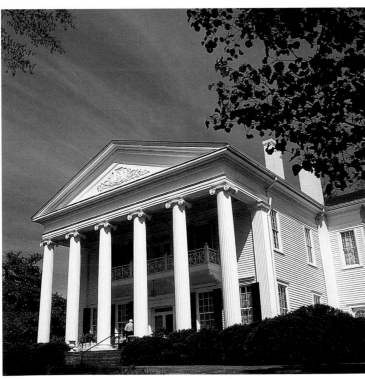

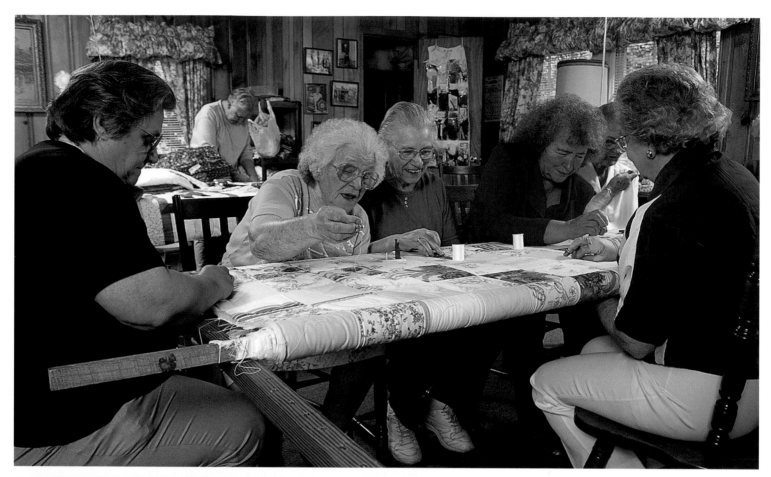

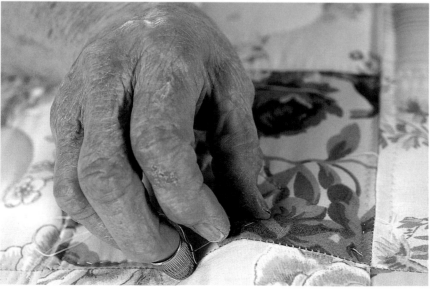

(above & left)
Dalton's Busy Bee Quilting Club was organized in 1941 to make clothes for the community's poor and to sew dresses for the women in war-torn Europe. The Busy Bee quilters now raise money for abused children.

(facing page, left)
Mr. Barton grew up in Floyd County making white oak split-bow baskets the way his father taught him.

(facing page, above)
Just as the Native Americans did, James Jennings of Dalton creates knives and spears by knapping flint.

(facing page, below)
Ed Packer carves his unique birdhouses in Cave Spring.

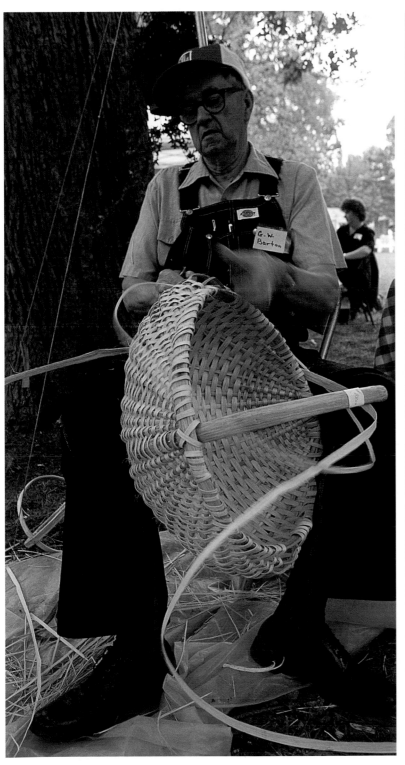
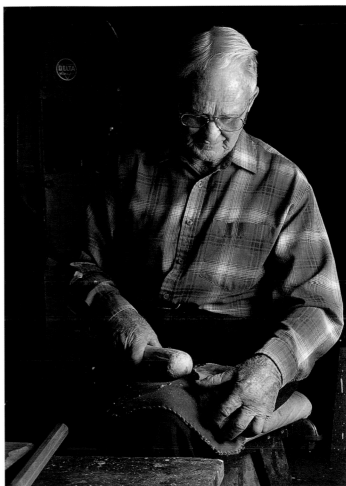
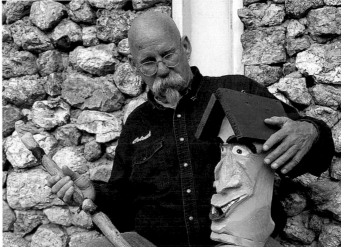

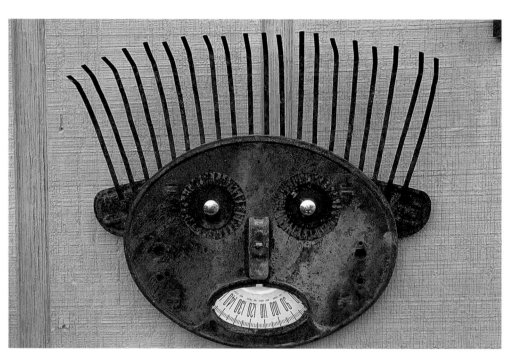

Self-taught artist Jim Shores of Cave Spring creates
yard art from discarded and found objects.

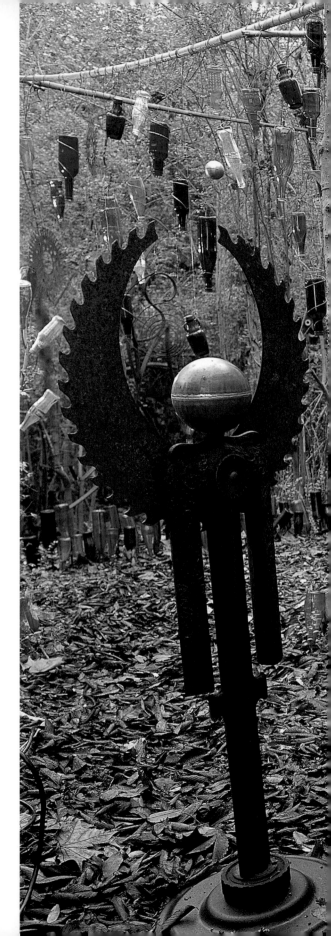

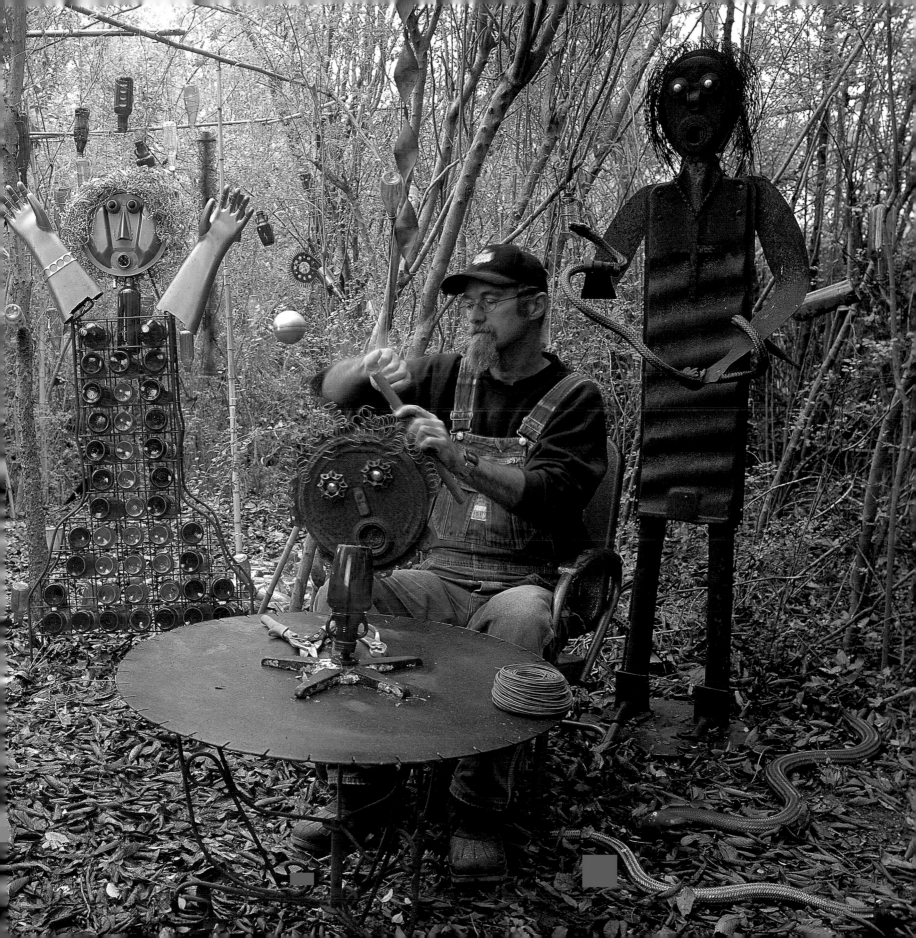

Lookout Mountain

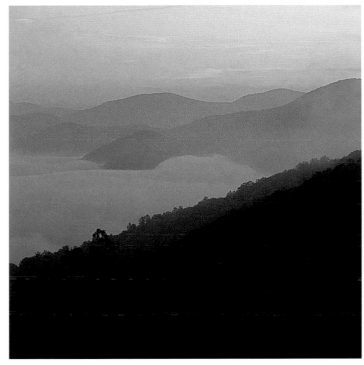

Black Rock Mountain State Park

The Chattahoochee National Forest

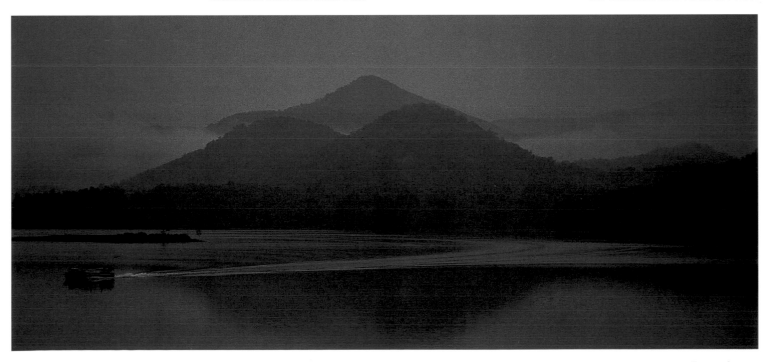

Towns County

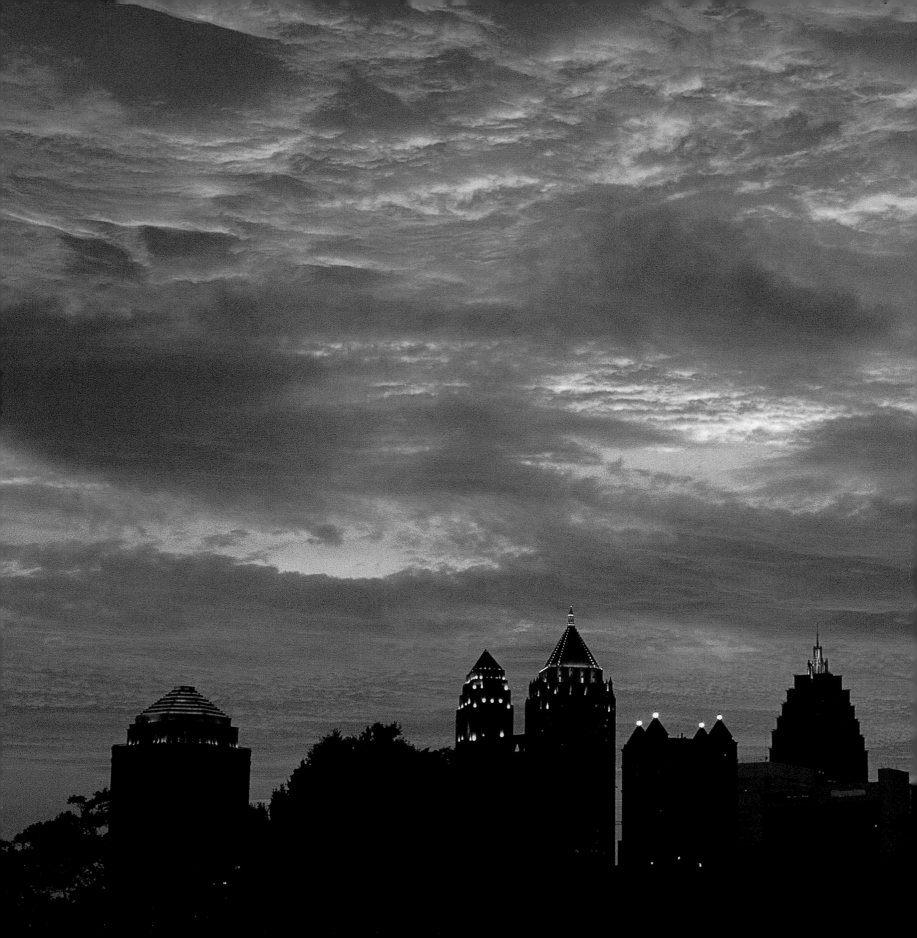

The Atlanta skyline

II. A Place and a Past:
The Dead Live Here Too

[A]

How do you regard the dead?
How do you regard the ways the dead have regarded you?

This evening, leaf by leaf,
 the hardwoods on Little Kennesaw are turning
a fiery yellow, though a few, as if remembering,
choose the color of crusted blood.

On the mountain today, only a few Girl Scouts wandering
the slave-dug earthworks . . . They are taking themselves back,
studying the ways the dead
 have made this place their own.

Now that you're here, take yourself back also,
bend down to this cannon and sight along the barrel—
paved road and pinewoods,
industrial park, railroad,
 the grassy field clotted with hardwoods,
all of this clotted then with a slaughter of bodies.
 Cannon fire,
smoke, the panic of men and horses . . .

 ——

A mile northwest, Pine Mountain.
General Johnston dismounts from his horse. He walks to a battery
near the crest of the hill
 and steps up onto the earthworks.

The rains have stopped. The roads are drying.
He turns his glasses toward the field—
a Federal tide washing toward the foot of Kennesaw.

Polk and Hardee converse with their aides.

All agree this hill is vulnerable.
Kennesaw is the place their armies must hold.
 Beyond there, the river
and Atlanta. Beyond there the rail yard and the end.

Cannon fire, smoke, panic . . .

———

In town,
on Church Street, the floor of Saint James is soaked with blood.
The cots of the wounded, soaked
with blood, lie like narrow doorways into a deep darkness.

Everywhere lies the unmendable body of a man or a boy—
the eye-shot, the mangled arm or hip, the hand
desperately holding in the bowels.

The surgeon at his table is finally exhausted.
His apron is stiff with blood,
 his right hand, washed in blood,
cramps around the saw.
The table is glazed with flies.
His bucket of severed arms and legs is glazed
with blood and flies.

———

Joe Johnston stands on the crest of his earthworks.

He trains his glasses north—waves of blue clotting the valley.
Shell whistle overhead, a blast up the hill.

His escort fans out,
and again he lifts his glasses, now toward the battery
that fired the shot.

Powder smoke hangs and drifts.

He steps off briskly toward the cover of the hill,
Polk, the bishop-general, trailing.

They step toward cover around the shoulder of the hill.

Whistle and shell blast, whistle and blast. He turns
and Polk has vanished.

—————

Do you think about the dead
and the ways the dead have made this place their home?

Think of Bishop Polk
as the shell gores his chest and explodes against a pine.

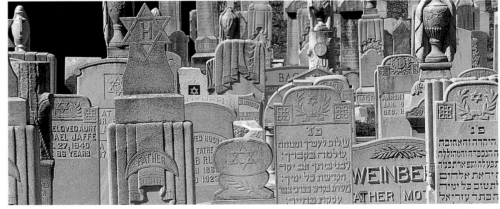

Historic Oakland Cemetery

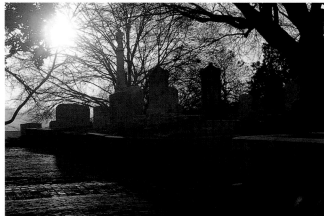

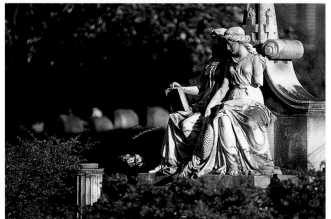

Historic Oakland Cemetery

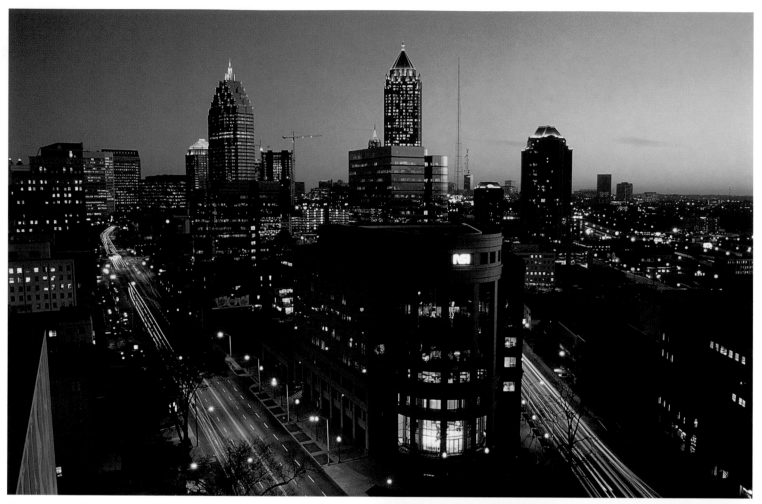

The Atlanta skyline

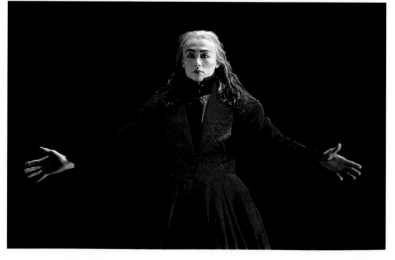

The Atlanta Ballet's *Dracula*

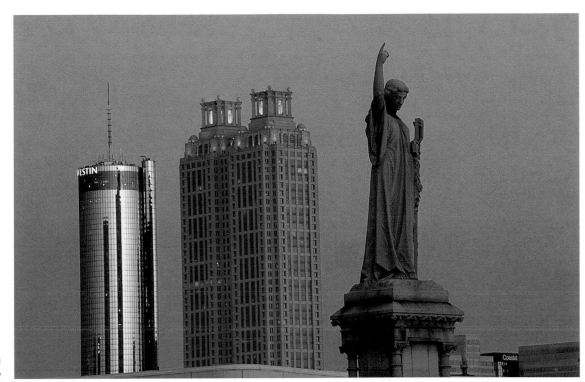

Skyline from
Historic Oakland Cemetery

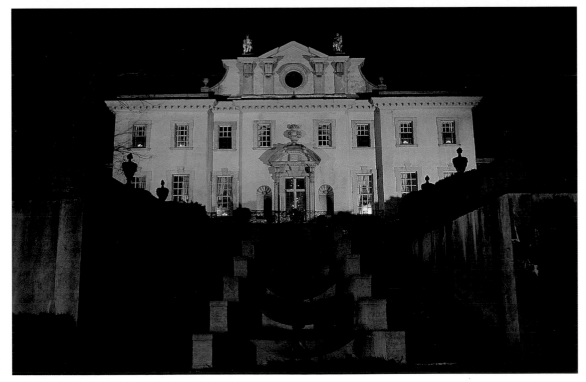

The Swan House,
Atlanta History Center

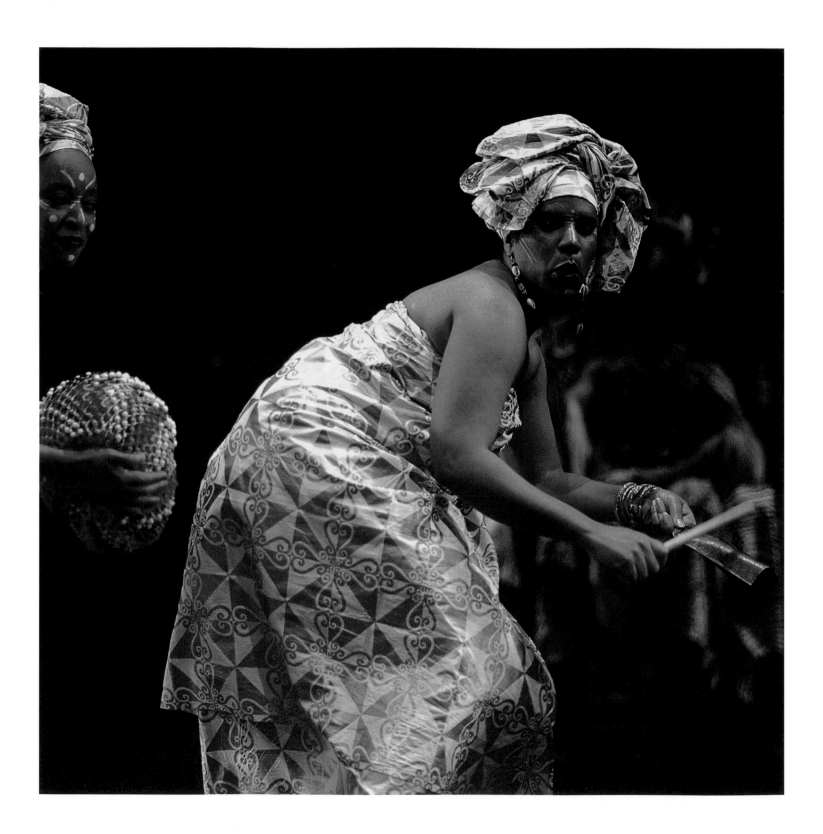

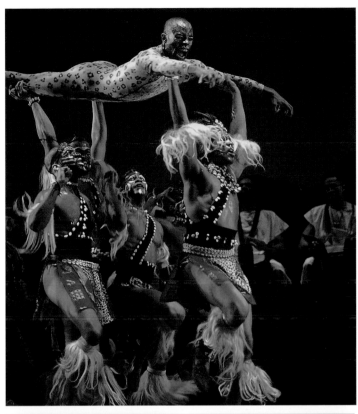

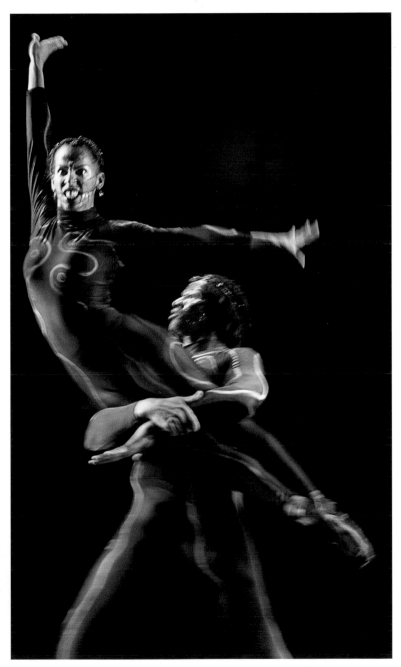

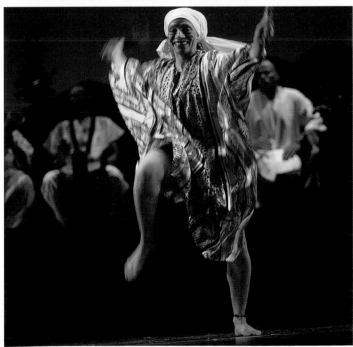

The Ballethnic Dance Company's *The Leopard's Tale*

[B]

On Auburn Avenue a few schoolchildren are thinking about the dead.

The bus pulls up to the curb, and to study the dead,
the children and their teachers
stagger, one by one, onto the sidewalk.
 The park ranger motions
and they enter the church.
They climb the steps into the sanctuary.

The red carpet is worn and stained, it shifts under their feet.
The pews and the pew cushions
are worn and stained. There is something in the air
 almost visible
in the stained light from the windows. In the large window
above the altar, Christ sends up a prayer.

Suddenly a voice rises bodiless from the pulpit.

For some it is enough to send them back.
In the bright minds of some,
 mourners are walking the streets.
They are walking from Morehouse to Ebenezer.
They are walking behind a mule and a wagon.
A few close by hear the creak
of the wagon. It hauls a heavy burden.

The past and the present are walking now together.
They are singing a hymn.

———

You too must go back.

You think your life is here—you here in the city traffic,
or among your customers at Macy's,
 your customers at the Post Office,
the tag office, the courthouse, your patients at Grady
or Crawford Long,
your colleagues at BellSouth, State Farm, Coca-Cola . . .

Lunch at Joel's or the City Grill,
 the Rib Shack on Auburn Avenue.
Dinner with family, dinner with friends. A movie at the Imax,
a concert at the Fox.

You think you know this place and who you are.

To know this place and your place in it,
you too must go back.

——

At the edge of the marble reflecting pool, the children stand quiet.
Though they are small and tired, they are not restless.

Red and gold leaves float on the water.
The sun striking the water
 turns the leaves into flames.

In the center of the pool, a white marble tomb. In the tomb
the remains of Martin Luther King,

in the white marble tomb
the body of Dr. King.

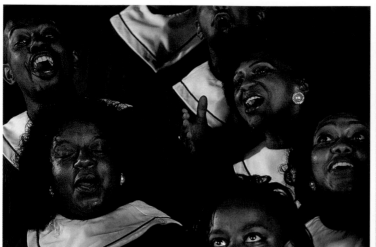
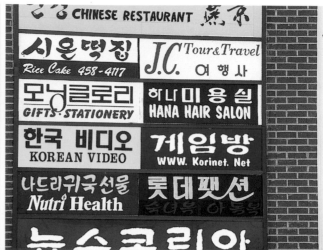

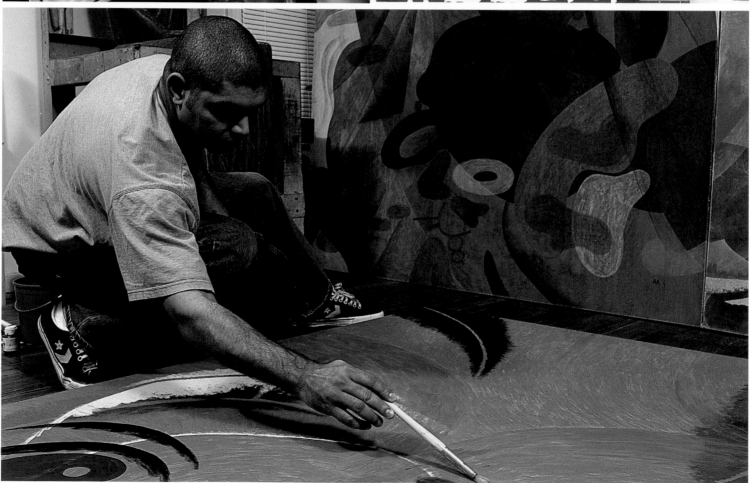

Atlanta artist Alejandro Aguilera

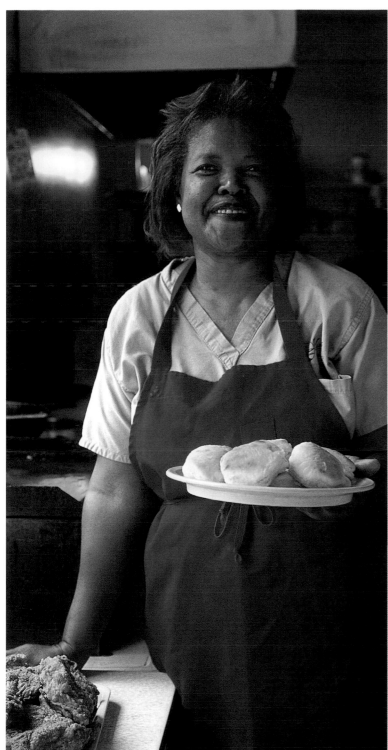

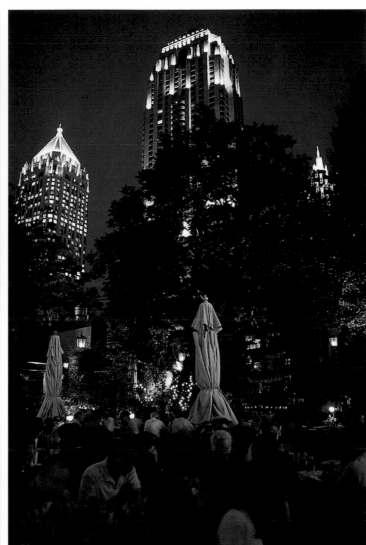

Scenes from downtown Atlanta

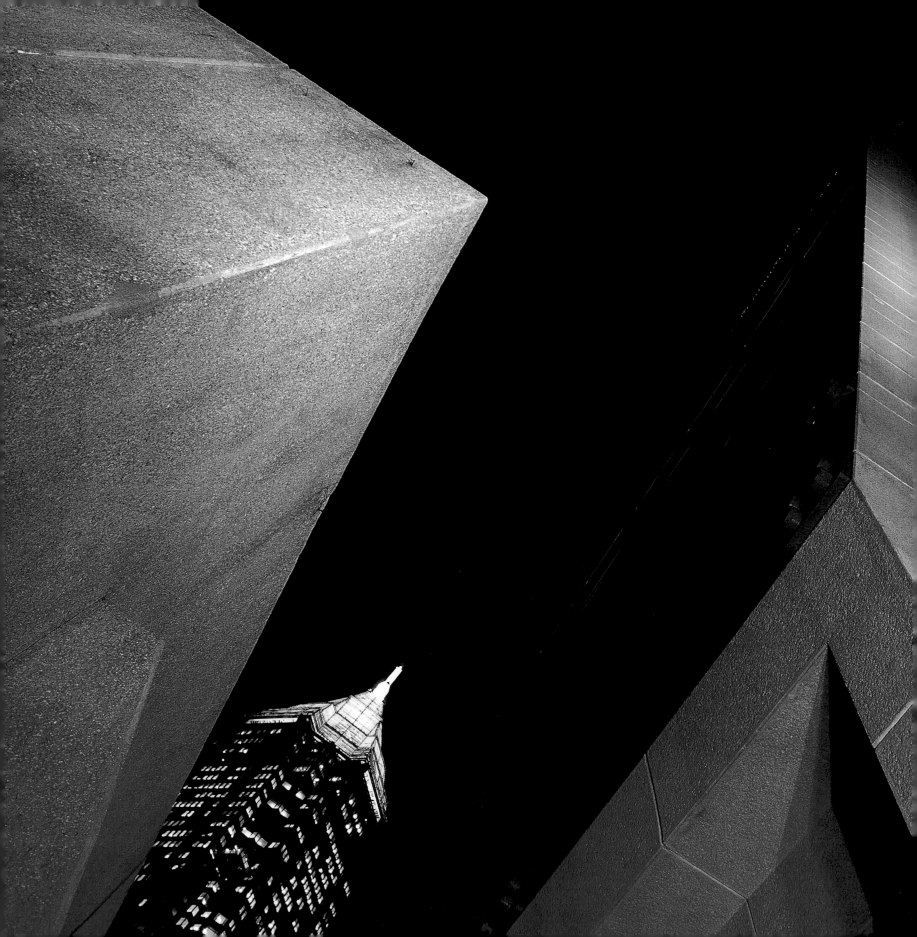

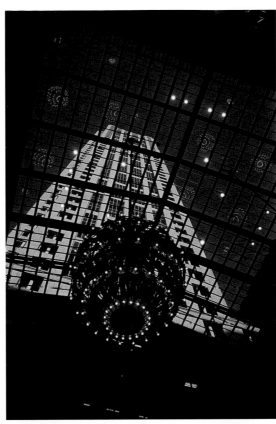

Scenes from downtown Atlanta

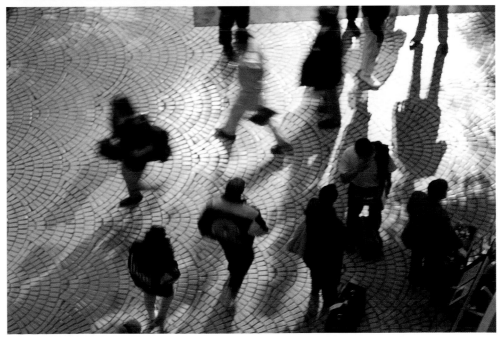

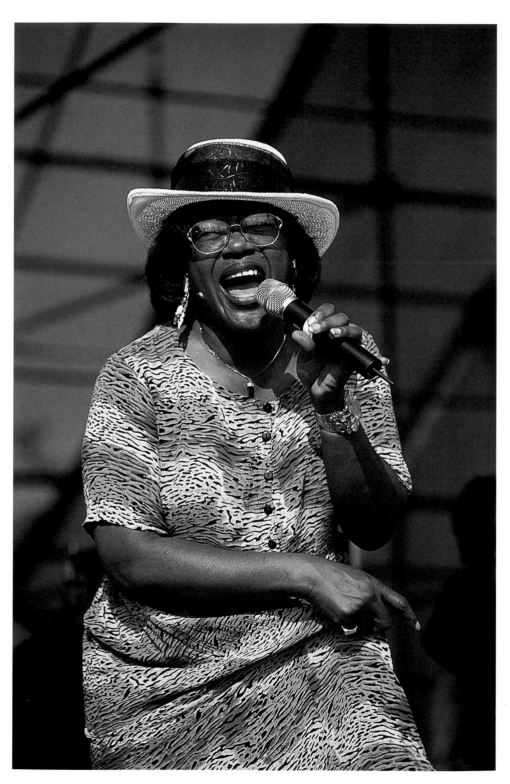

Francine Reed and the Georgia Mass Gospel
Choir at the Music Midtown Festival

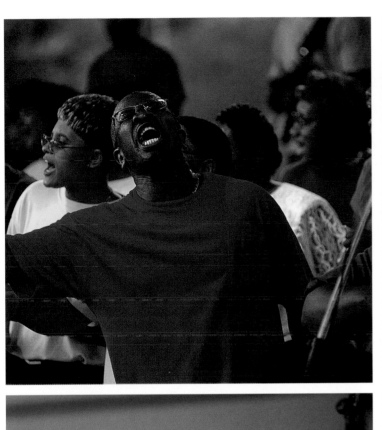
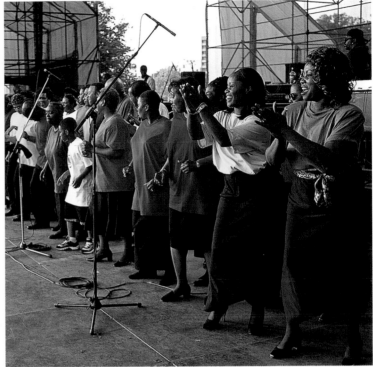
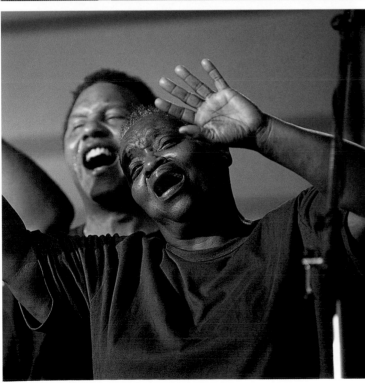
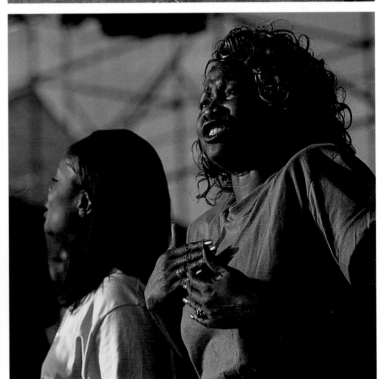

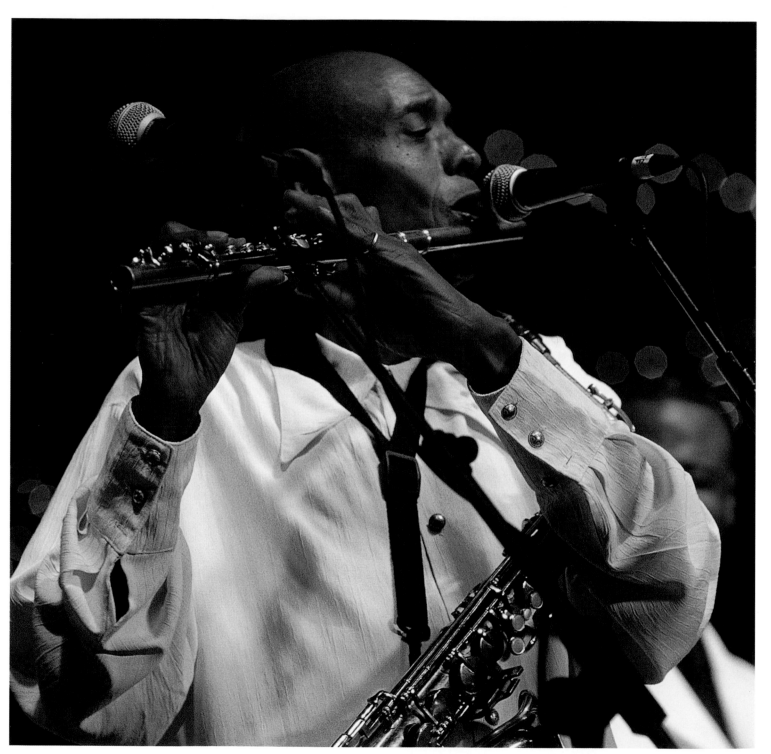

A member of the group The Brethren performing at Underground Atlanta

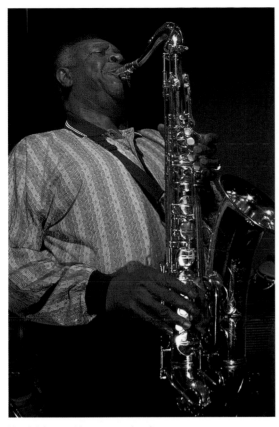

Hank Moore, blues saxophonist

The Atlanta Symphony performing in Piedmont Park

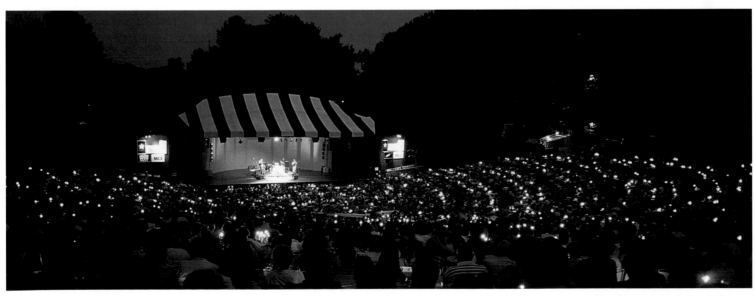

The Chastain Park Amphitheater

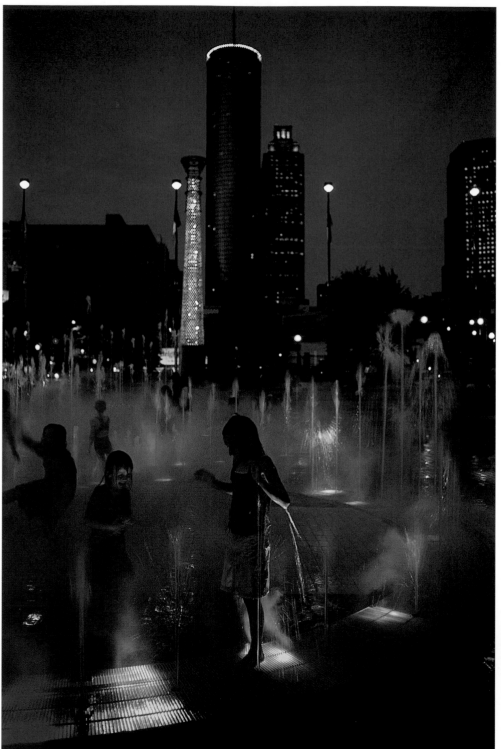

(left)
Centennial Olympic Park

(below)
Screen on the Green at Piedmont Park

(facing page, above left)
The Atlanta Ballet

(facing page, above right)
Stone Mountain

(facing page, below)
An Atlanta intown neighborhood,
Virginia Highland

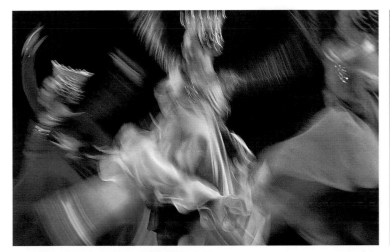

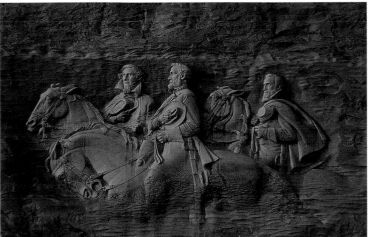

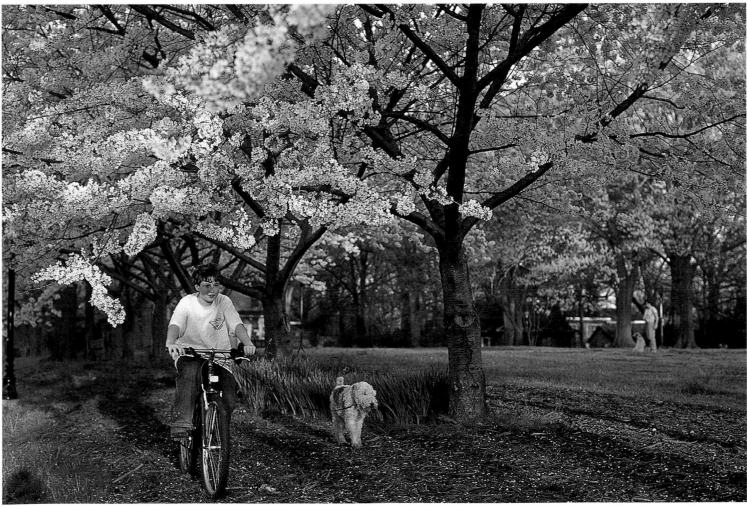

[C]

A crow strokes low over the river-swamp.
The wind drifts a few leaves
 onto the river, and the crow finds
the naked branch of an oak.

The crow has no past, but drifts in his own eternal moment.

You, though, have history. Here, a few miles east of Macon,
it goes back thousands of years—
 the crusted womb of the earth-lodge,
the burial mound, the temple mound, the fields
of the Ocmulgee Indians. How many baskets of history and dirt
in this one temple mound?

From the river-swamp
 the crow consults the overcast sky.
He has no past, but drifts in his own eternal moment.

You, though, have history. It sits like a crow on your shoulder.
It caws into your ear.

 ———

And sometimes you believe you understand.

Like a woman, say, visiting a cemetery,
a woman who turns
from a stained mausoleum to listen to the river and the rattling of leaves,
a woman who has never paused to listen.

She puts down her rice paper and anchors it with a stone.

She puts down her wafer of charcoal.

This woman who has come to Rose Hill
to rub the words from tombstones

 has turned to the river.

Here among the terraces in this gray municipality of the dead
lie none of her dead,

 though something
familiar rustles from Soldier's Square, from Hawthorne Ridge
and the bricked Victorian crypts along the river.

A rough voice across a great distance, almost caught.

She faces the river and listens.
The mockingbird in the mimosa discerns

 his own eternal moment.

An Atlanta intown neighborhood, Inman Park

The architecture of Atlanta

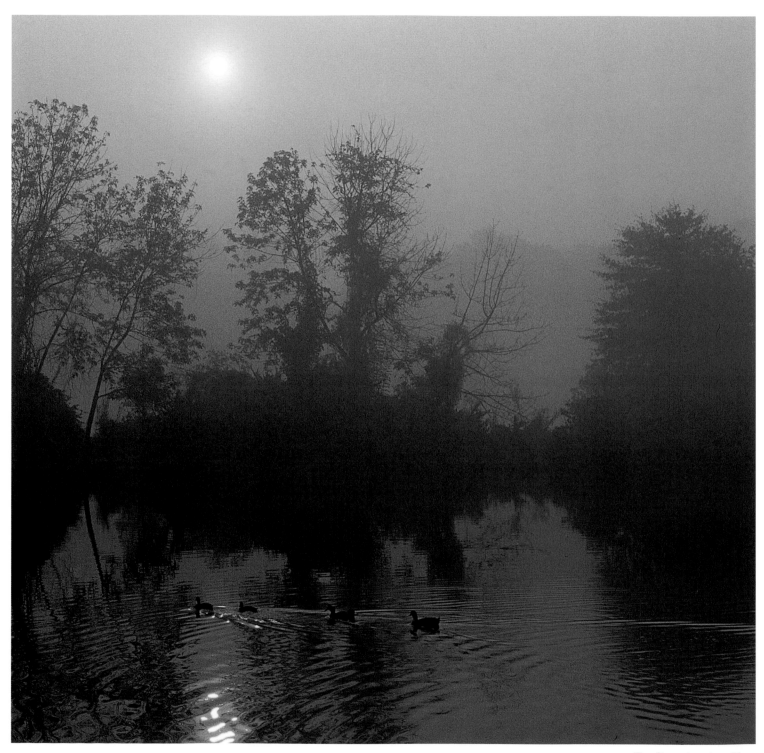

The Chattahoochee River

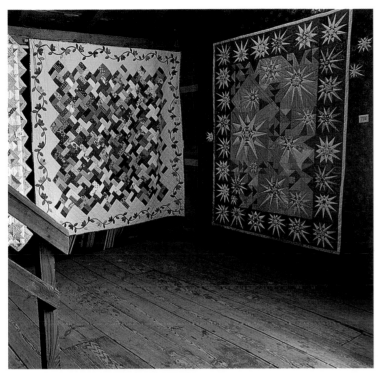

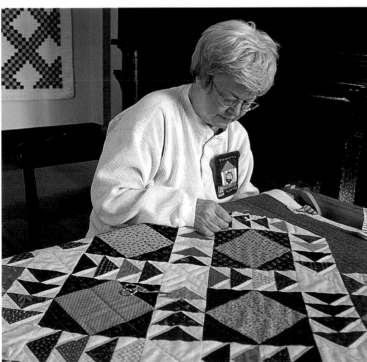

The Bulloch Hall Quilt Show in Roswell

(left)
Macon

(above)
Madison

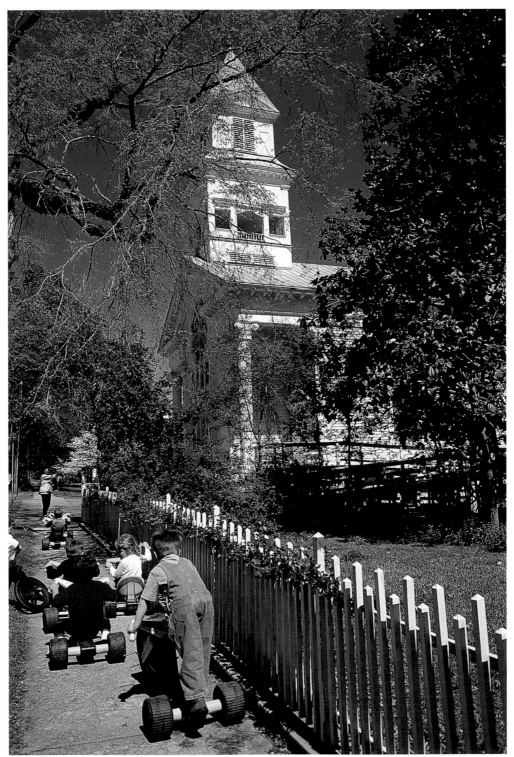

Eatonton

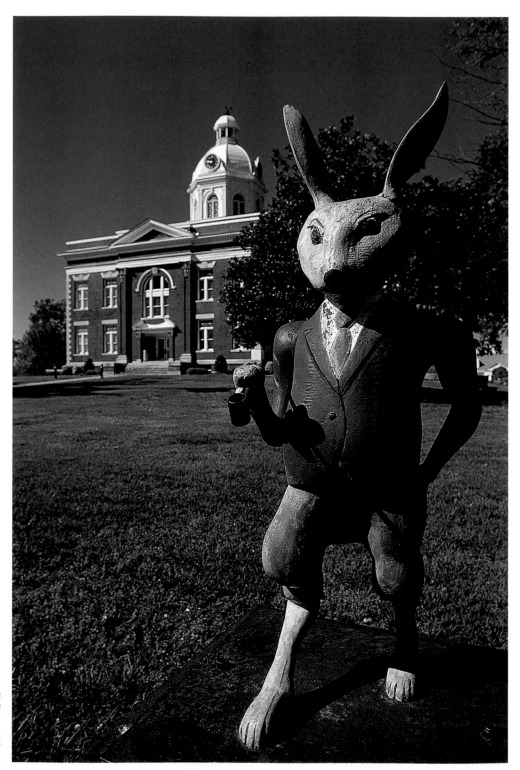

Joel Chandler Harris created the
Uncle Remus Tales from memories of
his childhood spent in Eatonton,
where a statute of Br'er Rabbit stands
on the courthouse square.

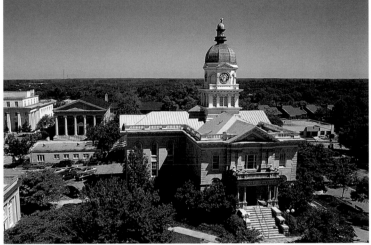

Athens

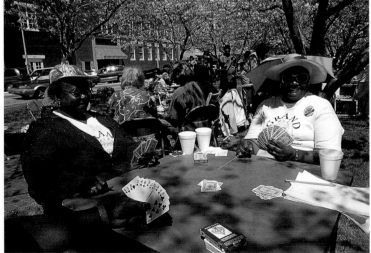

Macon and the Cherry Blossom Festival

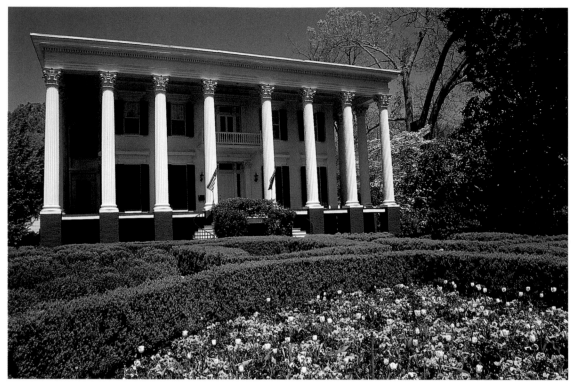

(left)
Built in 1856 and given to the University of Georgia in 1949, this Athens mansion now serves as the university's president's house.

(lower left)
Madison

(below & facing page)
Callaway Gardens

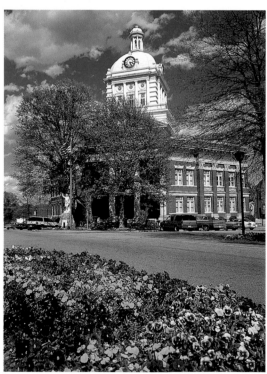

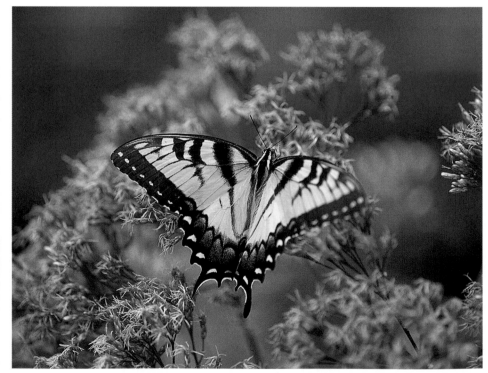

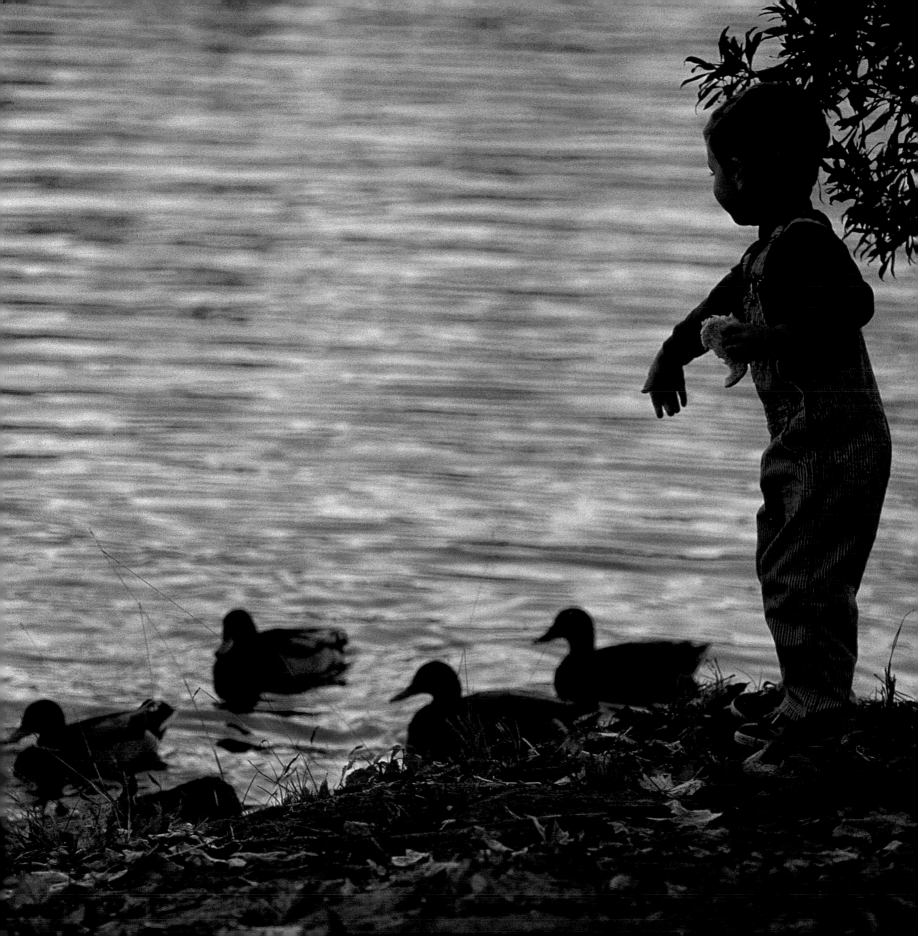

[D]

How do you regard the dead?
How do you regard the ways the dead have regarded you?

On the outskirts of Round Oak, an old man steps onto his porch.
His sagging house,
flaking paint, leans slightly from the pull of the moon.

The old man finds a chair,
 and a drab scrap of half-moonlight
finds the fiddle cradled in his arm, the bow rising
like a rod in Aaron's fist.

A few notes jar off his strings
and the tree frogs go quiet.
 The crickets go quiet, and the cicadas.

Dusty Miller? No, Sally Goodin,
and his bare foot scratches a shuffle on the planks of his porch.
After the Ball, Nellie Gray, The Maiden's Prayer . . .

His people are gone. His wife is gone,
his daughter moved to Dalton to work in a mill.

This is a way of remembering.

 ———

On Saturdays in Vidalia the veterans gathered at the hardware store.

Occasionally, there was pretense of something purchased—
a box of nails, some finishing screws, a tape measure—
but mostly the men talking.

Do you remember from your childhood the old men gathered?
Do you recall the dust on the bubble gum machine,
your father rocked back
 in a straight-backed chair?

An old man in a straw fedora is telling a story you've heard before.
The several men listening
 have heard it before.
The story has a fish in it,
and a leaking boat. At the bottom of the lake lies a deep truth.

What was that truth? Where has it gone?

————

Have you noticed that everything is disappearing?

Do you remember from your childhood the fragrance of magnolia?

In your backyard, a tree flowered.
 Each spring of your childhood,
a giant magnolia blossomed with Japanese lanterns.

Do you remember climbing those branches?

Where is that dark fragrance,
 that sticky kiss of blossoms?

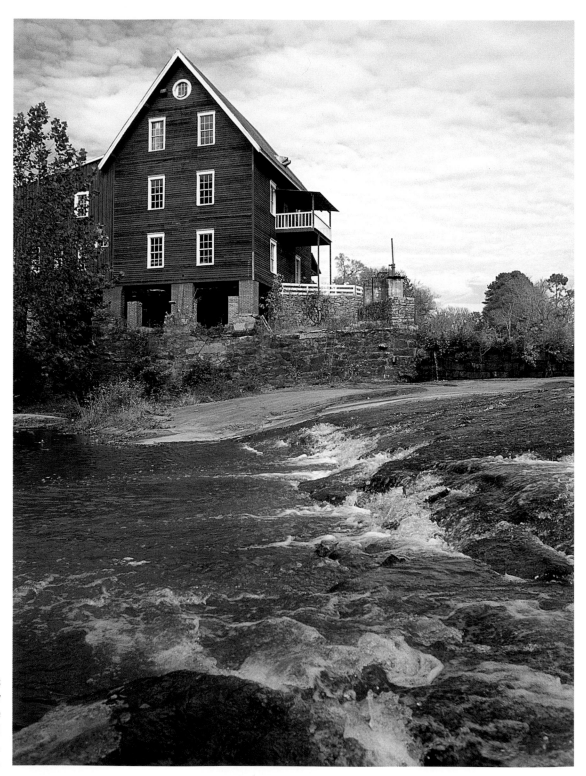

The waterfalls that occur as rivers pass from the relatively hard rock of the Piedmont to the softer rock of the Southern Coastal Plains powered fall line mills, like this one in Sparta.

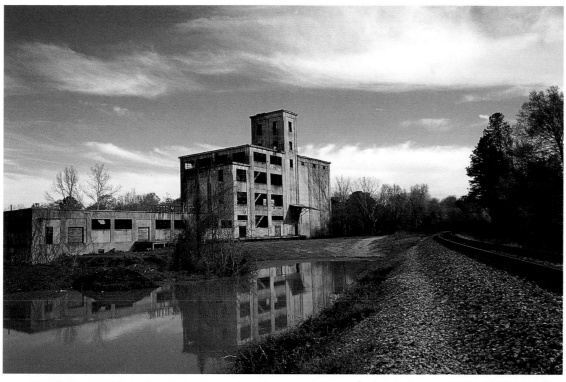

Abandoned mill in Juliette

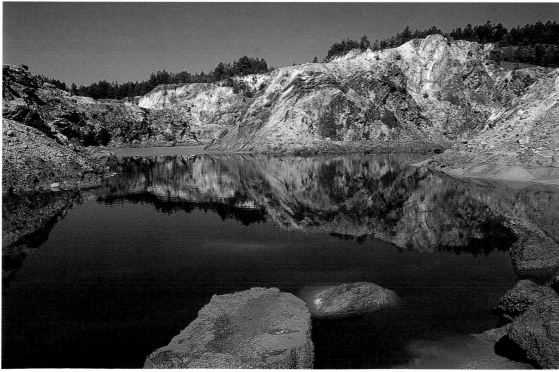

Graves Mountain in Lincolnton is popular with rock hounds searching for rare crystals and minerals.

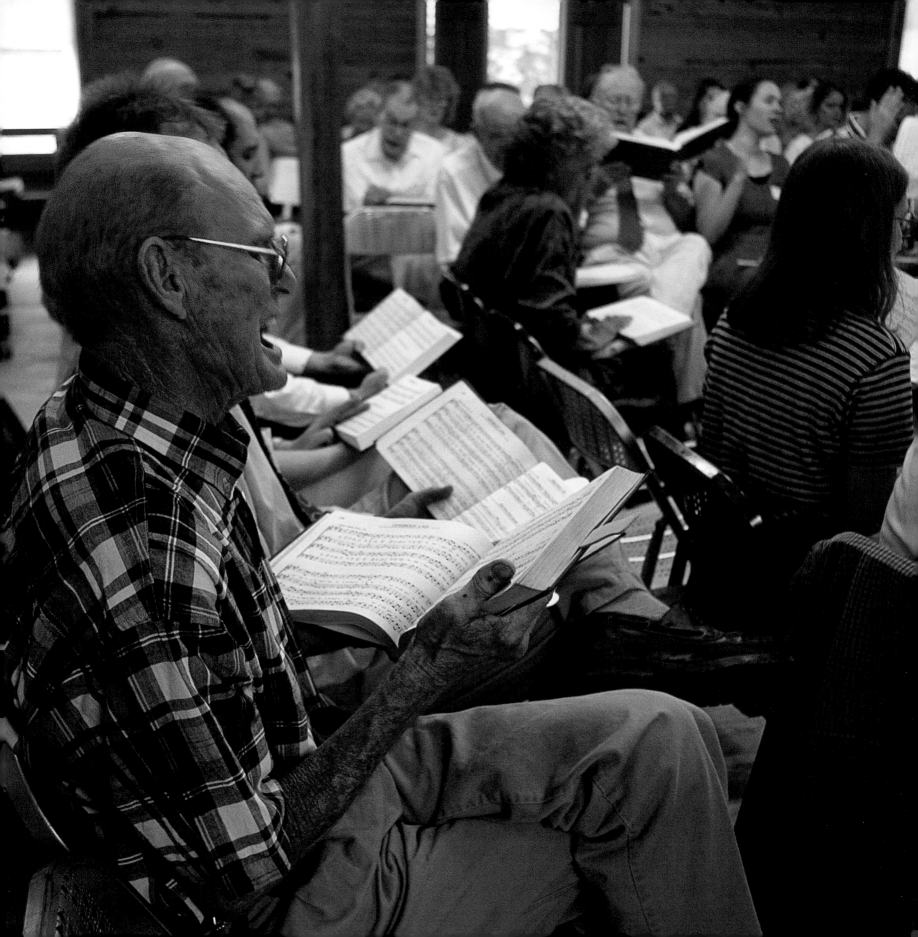

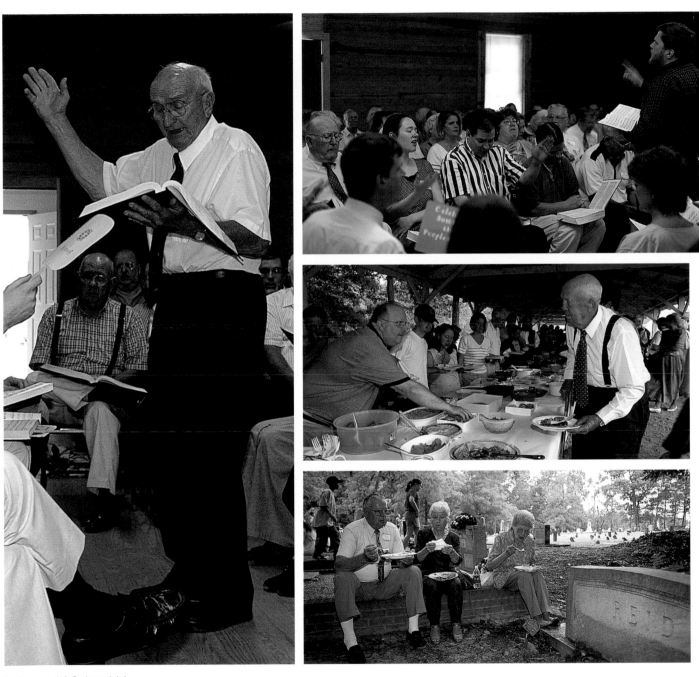

(facing page, left & above right)
Georgia has a long tradition of all-day Sacred Harp singings. Singers take turns leading the unaccompanied voices by beating time with their hands.

(right, center & below)
Chicken and dumplings, sweet potato casserole, and red velvet cake are staples when church members spread a feast of homemade dishes for a dinner on the grounds such as this one at Holly Springs Primitive Baptist Church in Bremen.

Home to nine Georgia governors, the 1839 Old Governor's Mansion still stands in Milledgeville.

Columbus' historic Riverwalk on the Chattahoochee

Conyers' Monastery of Our Lady of the Holy Spirit

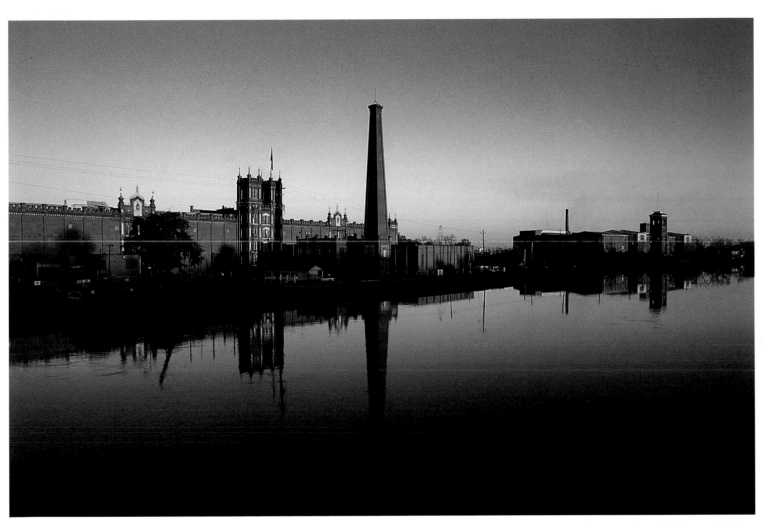

The Augusta Canal, constructed in 1845 along the Savannah River, provides beautiful walking/biking trails and supplies hydropower to textile mills such as this one, built in the nineteenth century.

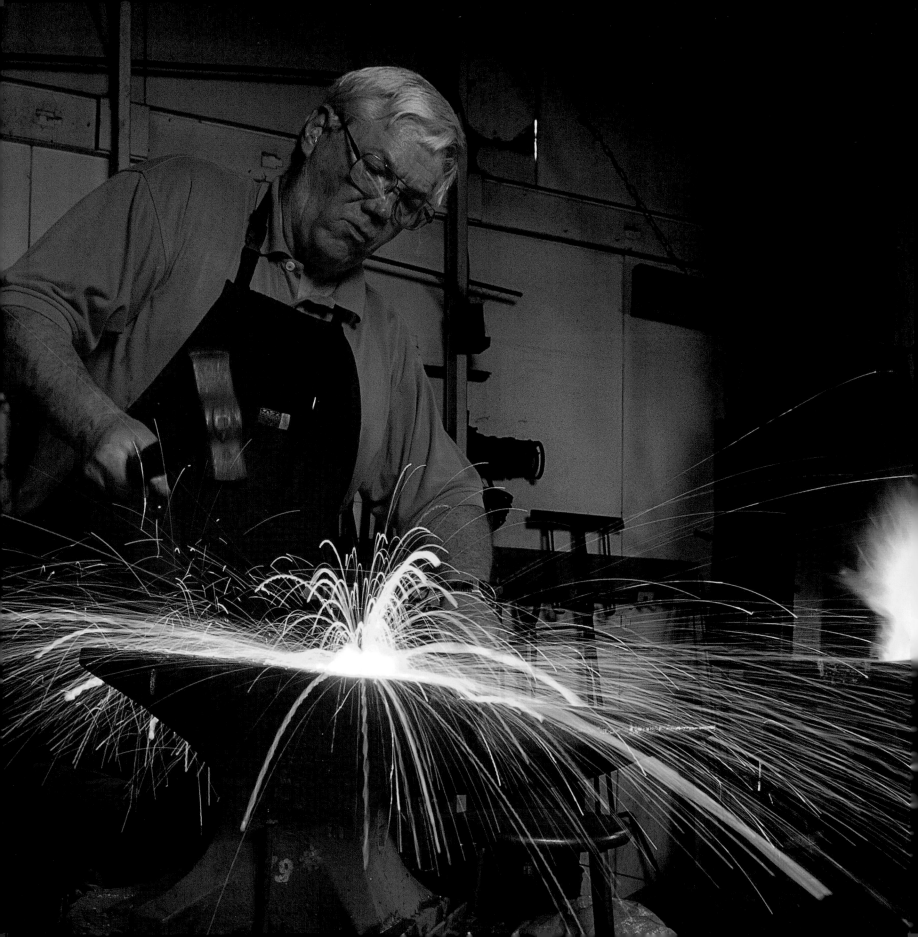

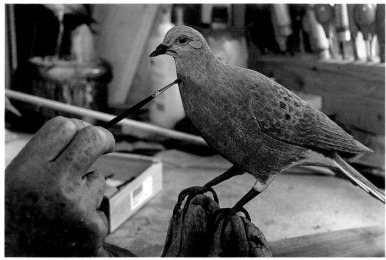

(facing page)
Newnan blacksmith Dan Tull

(left & below)
Bob Williamson carves and paints intricate birds in Williamson,
the town his grandfather founded.

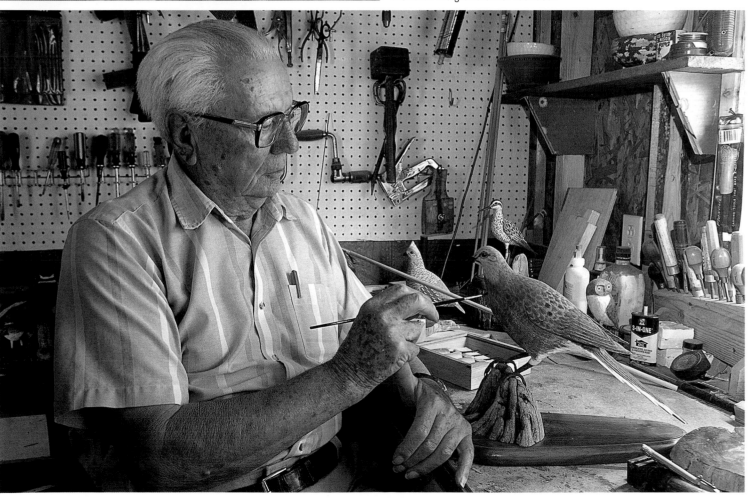

[E]

The wake of the johnboat ripples the cove.

The fisherman drops anchor, a concrete block, and reads the banks—
brush cover and a downed pine
 where a turtle soaks up sunlight.

He uncorks the basket of crickets and shakes one into his hand.
He turns and leans for his daughter's line.

Far off in the woods the early chatter of squirrels,
a blue jay rising off a dogwood . . .

He leans and reaches for his daughter's line.
She is small and sun-blonde, a mop of hair in a life jacket.

This is also history.

 ————

A woman turns the page of a book.

In the weak light of the table lamp, the page is mostly shadow.
The child is not quite asleep. Under the quilt,
his head on the pillow,
 her son is not quite asleep.

The woman turns the page, and the children in the story
leave their path for the deeper woods.
 The boy under the quilt
knows they shouldn't stray from home. He knows
they should stay by the fire and their family.

Why, he wonders, is this so difficult?
 Why, he wonders,
is he walking now with them, a few steps behind
but walking with them?

The woods are getting darker.

———

In a restaurant in Atlanta, a young couple has ordered lunch.

They are outside on the patio
and the green awning above them drips slowly from the passing shower.

She thinks he is not quite handsome. He thinks
she is not quite beautiful.

They don't hear the traffic on Peachtree, the noise in Woodruff Park.
They don't hear the pigeons hustling on the sidewalk.

She reaches across the table to touch his hand.
He moves his hand closer.

She shares with him a memory of another hand,
calloused, hard.
 He shares with her the memory of a woman's hand.

One hand holds a cricket, the other a book.

———

You too must go back.

You think your life is here—you here in the city traffic . . .
To know this place and your place in it,
you too must go back.

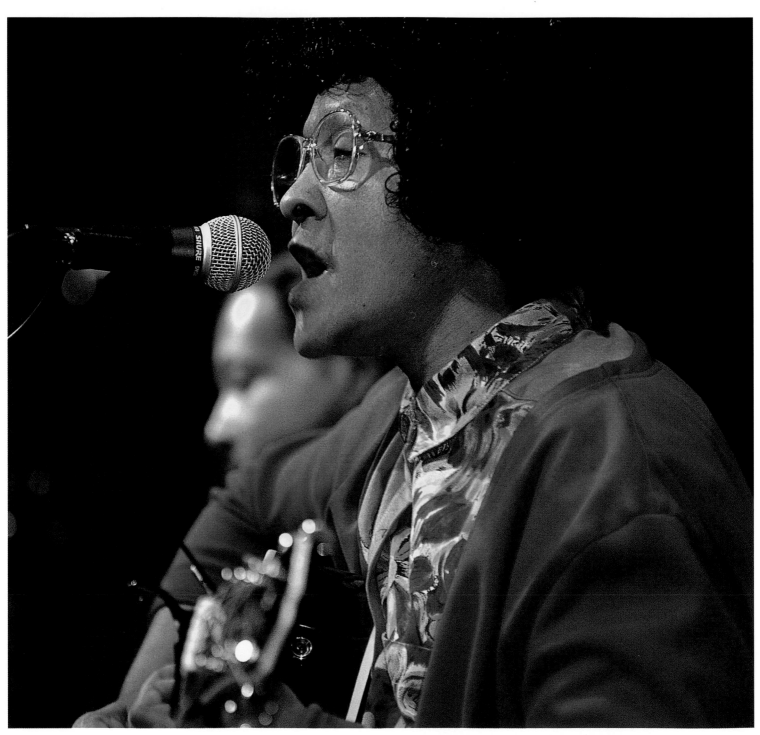

Precious Bryant, a down-home blues musician, taught herself to play the guitar by
listening to the radio as a child in Talbot County.

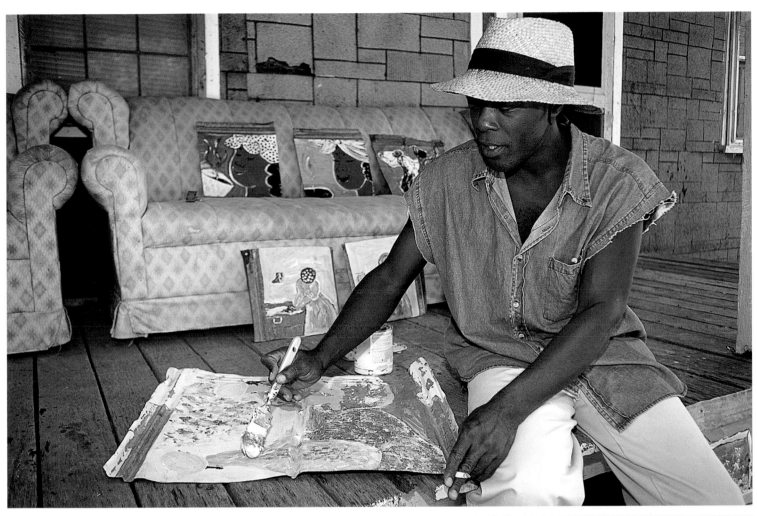

Self-taught artist Leonard Jones
paints scenes from memory on scraps of tin in Lincoln County.

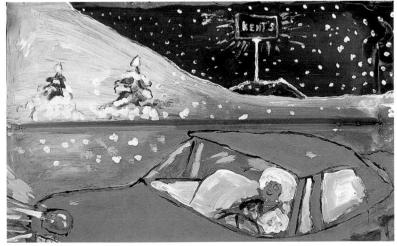

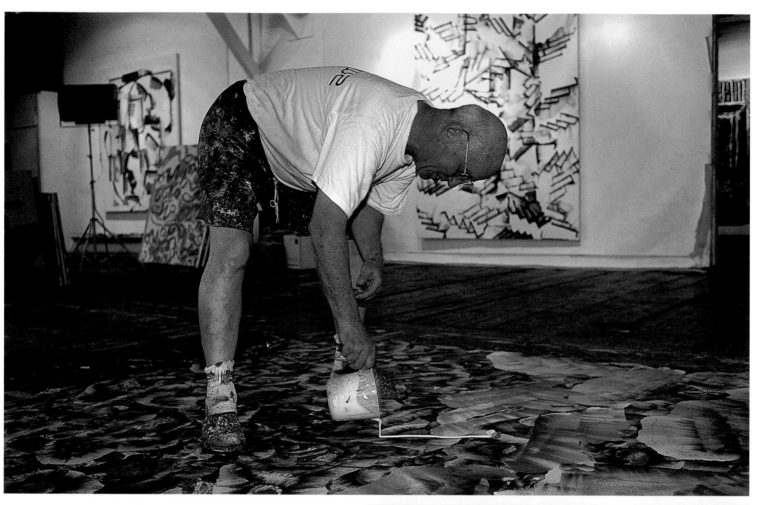

Herb Creecy works on his abstract drip paintings in
a restored Barnesville warehouse.

(left)
AthFest features the latest in new rock music.

(below)
The Lewis Family of Lincolnton has been entertaining for fifty
years with their special blend of bluegrass gospel music.

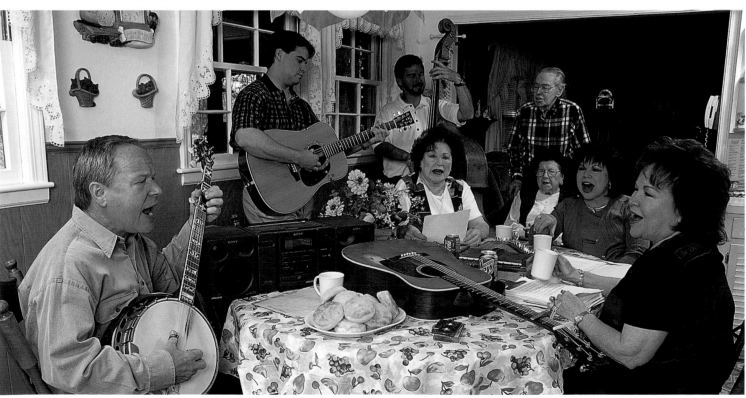

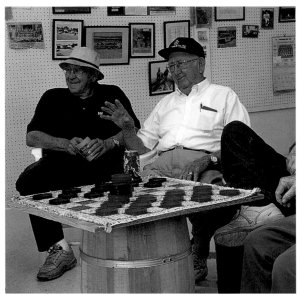
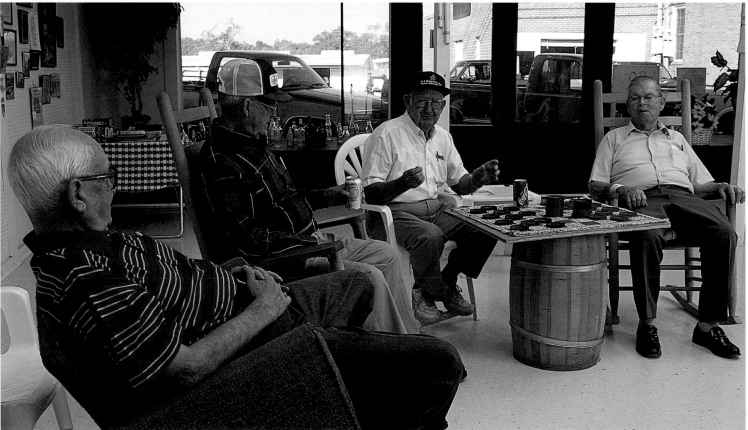

Every morning locals discuss the issues at Jip's Sit-A-Spell in Lincolnton.

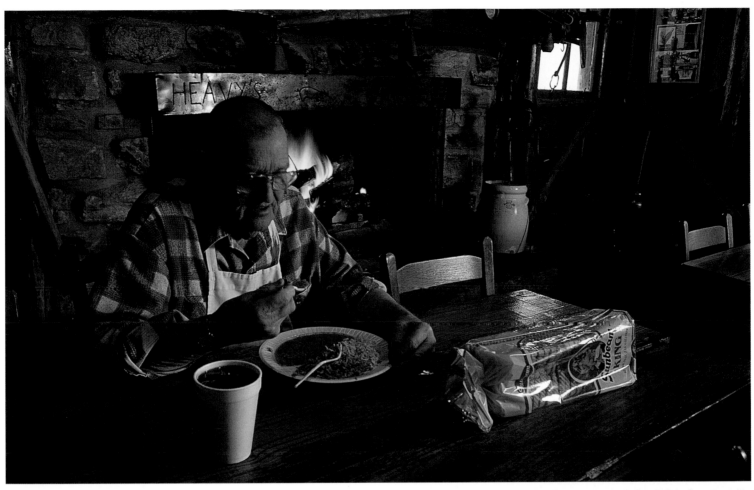

Heavy Grant at Heavy's Bar-B-Q in Crawfordville

Senoia

Louisville

The William Harris Homestead in Monroe, built in 1825

Sweetwater Creek State Park, Douglas County

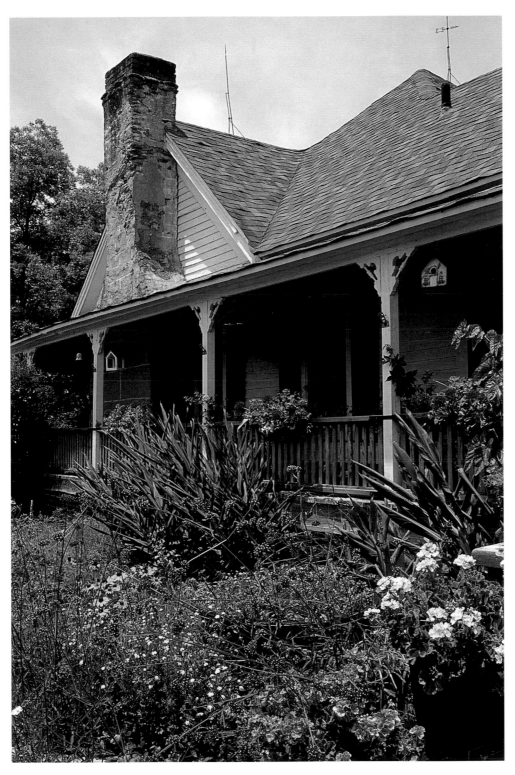

Acres of wildflowers and pecan
orchards surround Ruth and Dennis
Mitchell's 1849 home place in
Orchard Hill.

III. A Past and a Mission

[A]

Do you revere the dead?
Do you revere the ways the dead have revered you?

A man stood on the bluff of a river
and imagined a city.
 The river here forms a Half-moon,
around the southside of which the banks are about forty feet high,
and on the top a flat, which they call a bluff

Seven weeks and not a calm crossing. Two infants lost to sickness,
though otherwise no calamity,
 but not a calm crossing.
Seven weeks of winter on the frigate *Ann*,
and a hundred or so colonists with their thick Protestant Bibles,
their axes, muskets, plows,
10 tons of Alderman Parson's best beer . . .

The Savannah River formed a half-moon,
the banks were high.
 Upon the riverside, in the center of the plain,
I have laid out the town, opposite
to which is an island of very rich pasturage.

———

The Savannah River

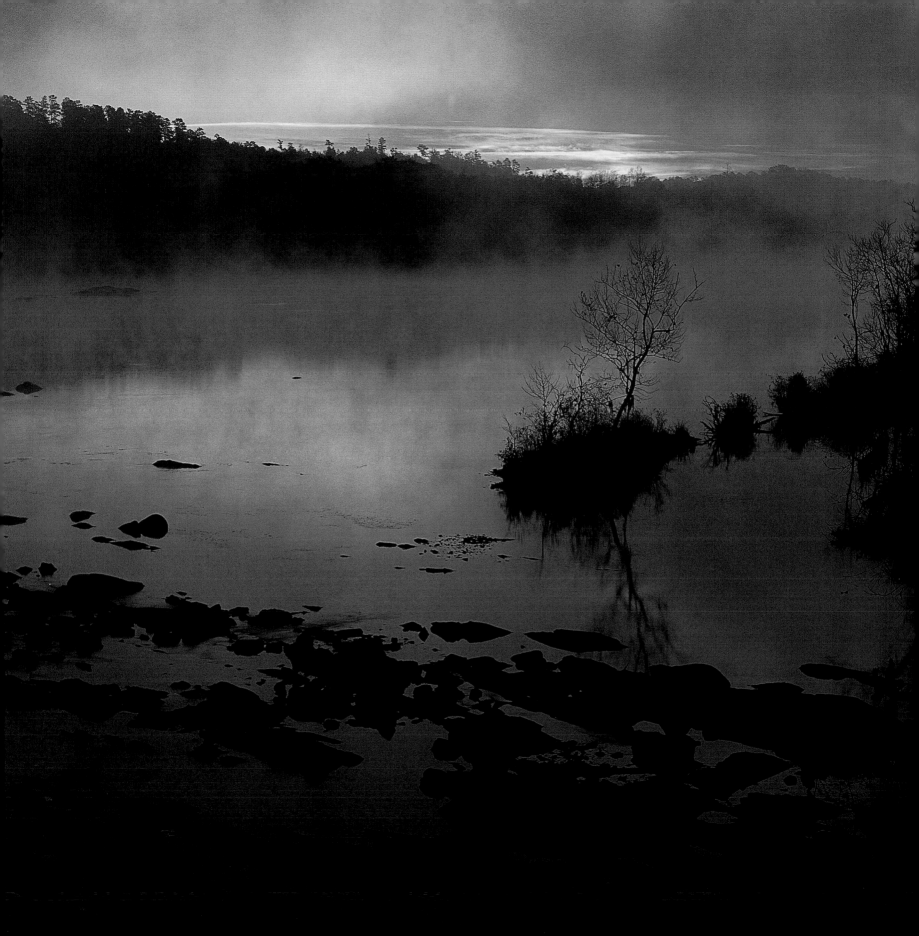

A winter crossing, but in Charles Town a good reception.

Their last Sabbath in Old England had been spent together
in prayer,
 so their first in their new home was devoted
to prayer and thanksgiving.

Yes, he was grateful.

As was Governor Johnson and the assembly of Carolina,
who welcomed him as a buffer
against the Spanish
 and offered good words, stout handshakes,
boats to carry his people to their design'd settlement,
105 head of cattle, 25 hoggs,
and a quantity of rice for provisions.

———

They pitch four tents on a bluff above the river.

The osprey circling the oak grove cuts his eye to the bluff,
and the fox in the pine thicket,
 the marsh rabbit, the curious crow.

The vultures circling the far pines and the village of the Yamacraw
cut their eyes to the bluff.

Four tents among the bay and moss-draped oak, the cypress,
the sweet gum—a labor drenched
 in the fragrance of jasmine.

At twilight a large fire centers the settlement.
He sleeps in the open
 beside the fire.

 ———

If any of them are sick, he immediately visits them . . .
If any difference arises, he is the person who decides it.

It is surprising how cheerfully the men go to work, considering
they have not been bred to it. There are no idlers . . .

He has plowed up some land, part of which is sowed with wheat,
which is come up and looks promising.
He has two or three gardens
 which he has sowed
with divers sorts of seeds
and planted thyme with other pot-herbs,
and several sorts of fruit-trees.

In short, he has done a vast deal of work for the time,
and I think his name
deserves to be immortalized.

 ———

The Indians who are thereabouts
are very fond of Mr. Oglethorpe and assist him what they can;
and he, on the other side,
 is very civil to them.

 ———

A dream owned him.

It was a new idea, fragile, perhaps old-fashioned. He thought it good.

His dream was rich soil and sunlight. Rain and hard labor,
the free farmer on his own land.

His dream was opportunity.

He lived it by his labor. Hard work,
the free man and the free woman
 working their own farmland.

Slavery, he wrote, *is against the Gospel,*
as well as the fundamental law of England. We refused as trustees
to make a law permitting such a horrid crime.

He made enemies.

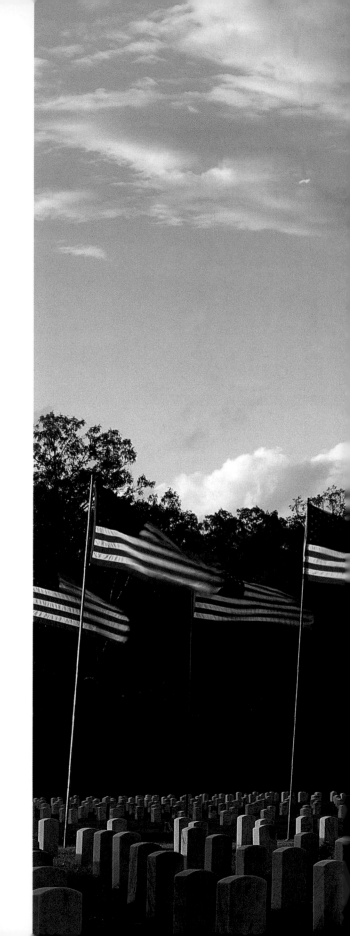

After the Civil War, Clara Barton (founder of the American Red Cross) cared for
the wounded at the overcrowded Andersonville Prison. She planted four magnolia
trees in the center of the burial grounds to commemorate the suffering of the
thirty-five thousand Civil War captives imprisoned at Andersonville.

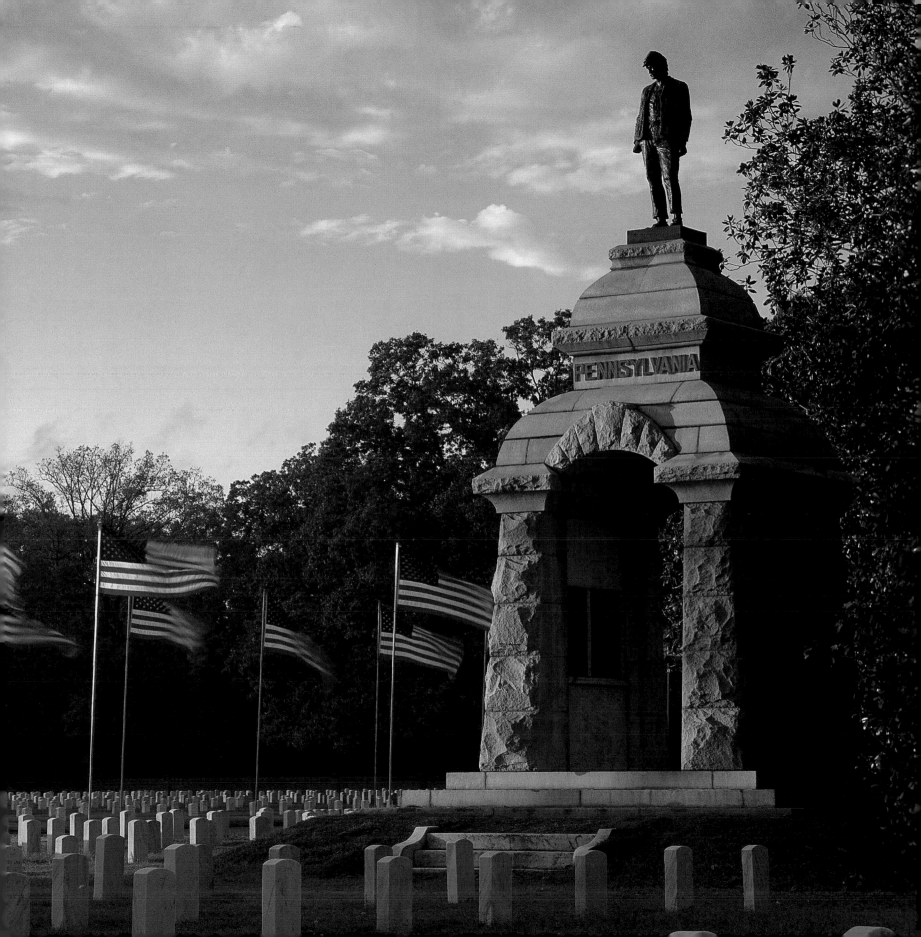

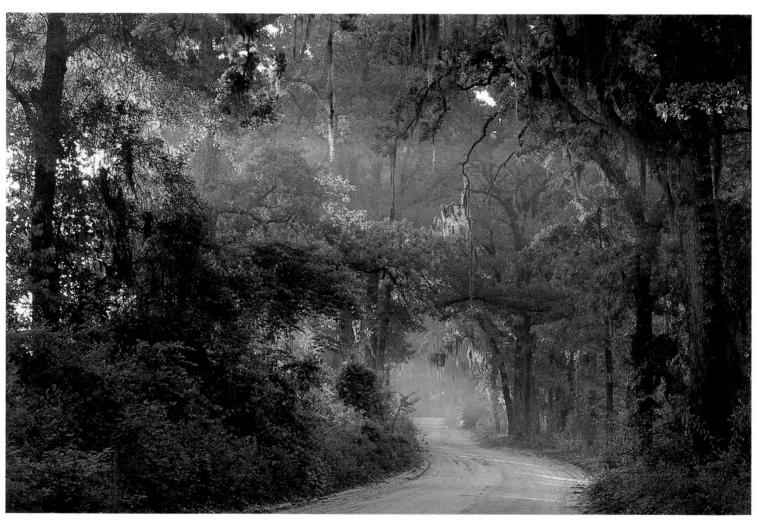

Baker County

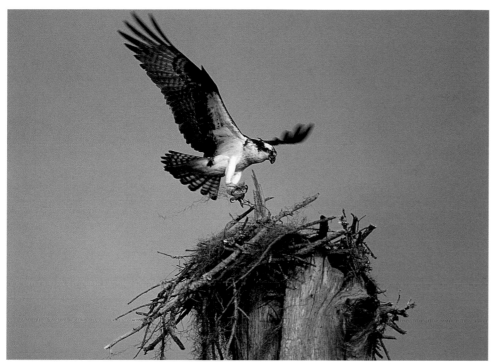

Osprey at Lake Seminole

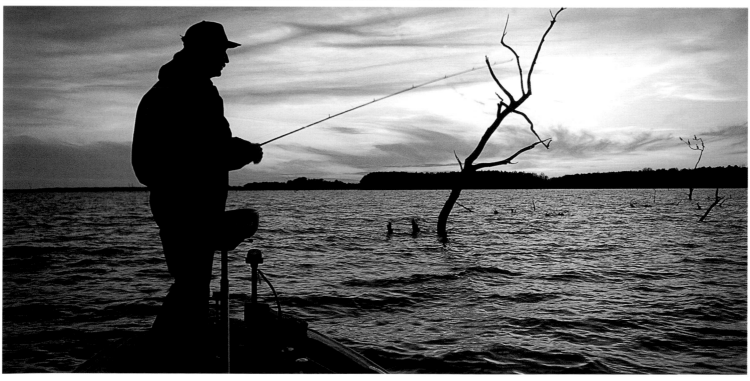

Lake Seminole

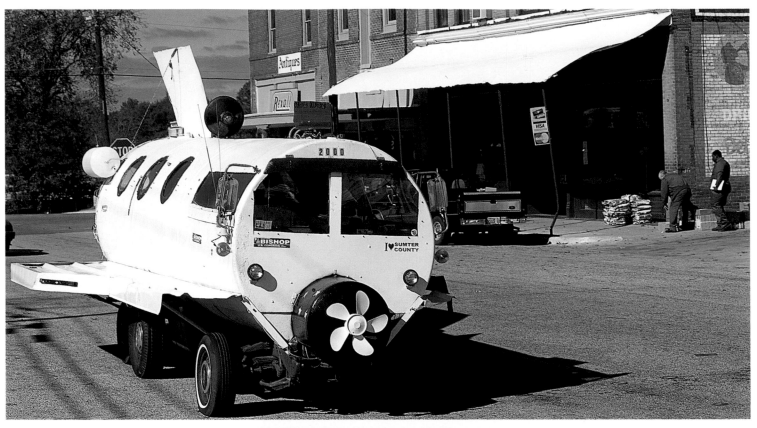

It took Buena Vista's Albert Colbert ten months to complete his homemade space shuttle, complete with seats, a starry ceiling, an 8-track sound system, and a "black box recorder."

In Savannah, Gulfstream is recognized by business and world leaders as the finest business aircraft ever built.

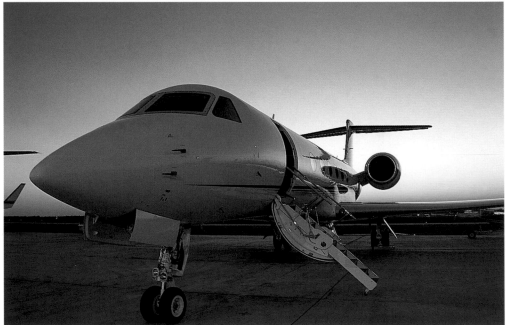

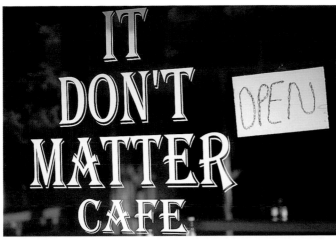

Café in Americus

Quail Motel in Blakely

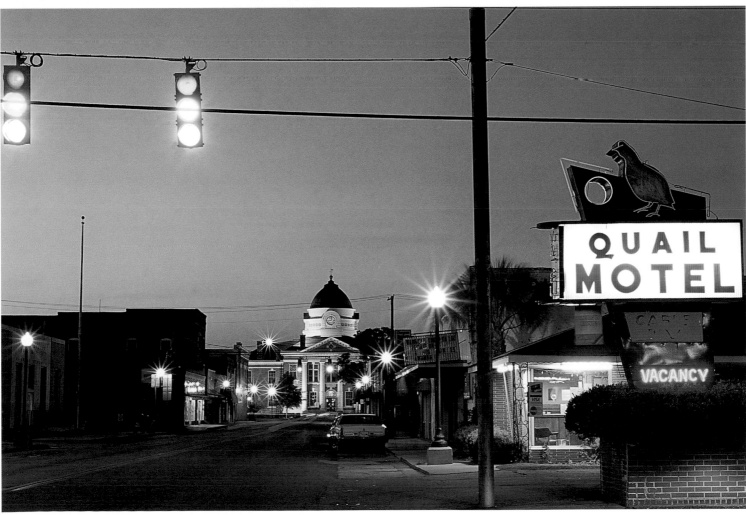

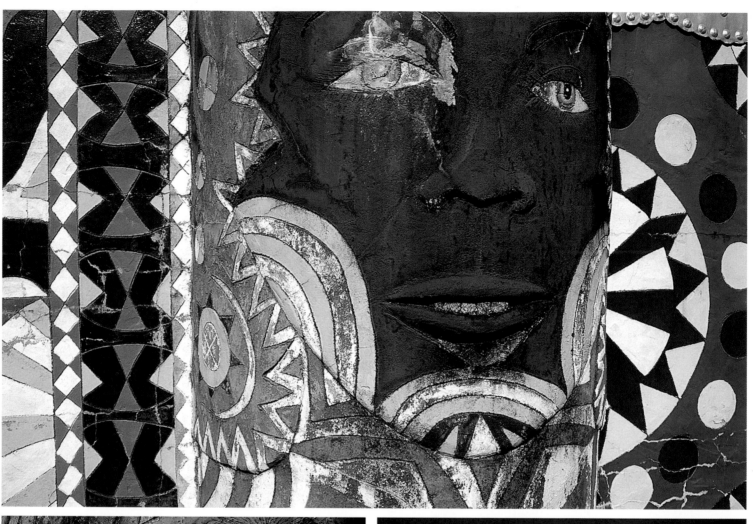

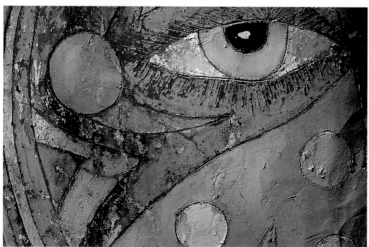

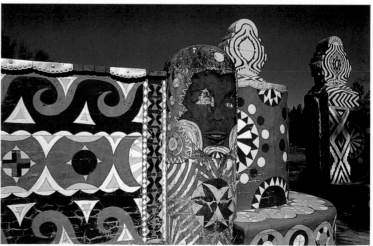

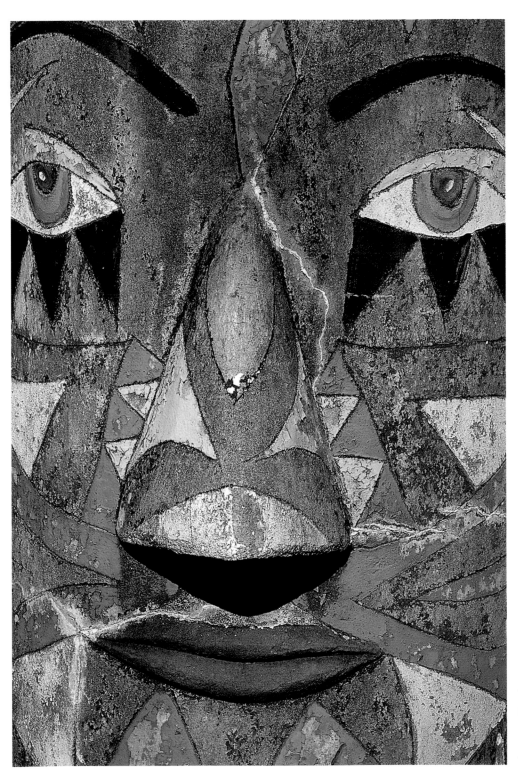

The eccentric St. EOM began working on Pasaquan, his visionary environmental art, near Buena Vista in the late 1950s and continued until his death in 1986. The resulting complex depicts the artist's vision of the future.

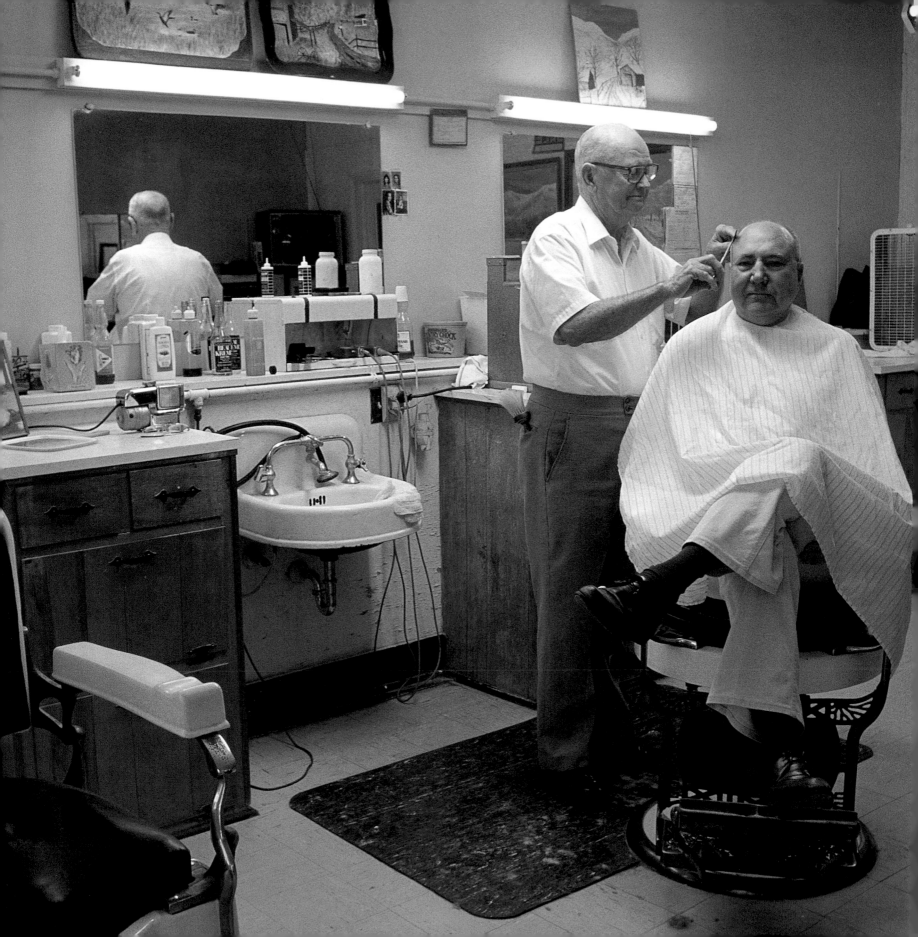

(facing page & right)
Tifton

(below)
Columbus

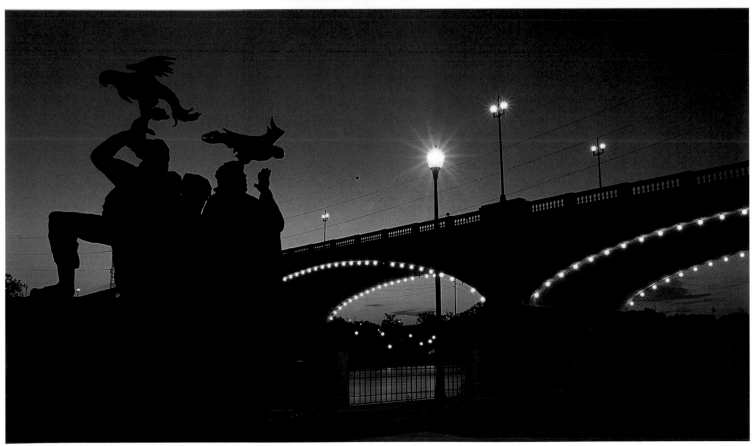

[B]

Andersonville, November 1863. The wounds of history fester.

Fresh water makes it attractive, and its proximity to the railroad.
Also, it's far south, away from the Federal lines,
and has no real population
 to protest a prison.

They wall the stockade with slave-cut pine log set vertically
in a ditch five feet deep.

A creek runs down the stockade's center.

Orders are given, and orders are followed.
The trains arrive with their ragged prisoners. They flood
from the boxcars.
 Many sick, many malnourished.

The creek fills up with human filth.

Inside the wall runs a shorter fence, the deadline.
Anyone caught beyond is shot. Yes, prisoners are shot.

But mostly they die of disease, malnourishment, exposure.
There are tents but not many.
 In fifteen months,
thirteen thousand die.

———

You must open history.
You must open it like a sealed envelope and read your orders.

Unfold the paper and move to the window.

What is your order of the day?
What does history require?

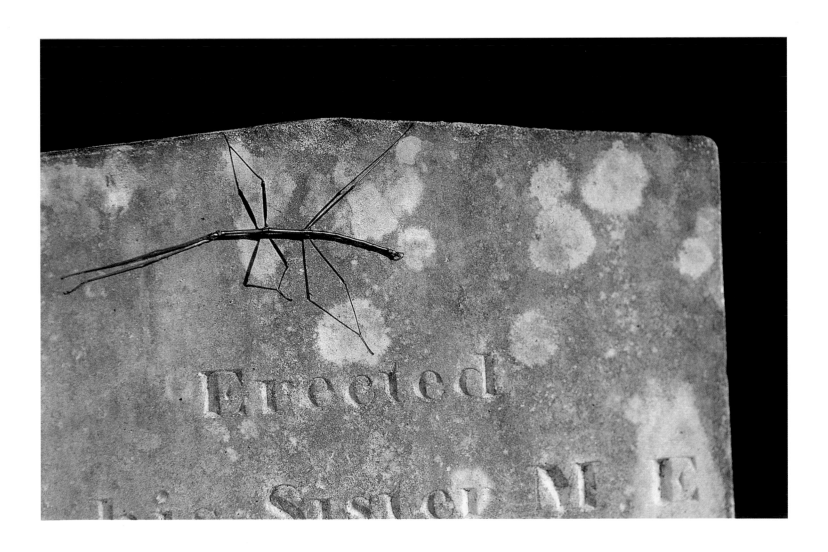

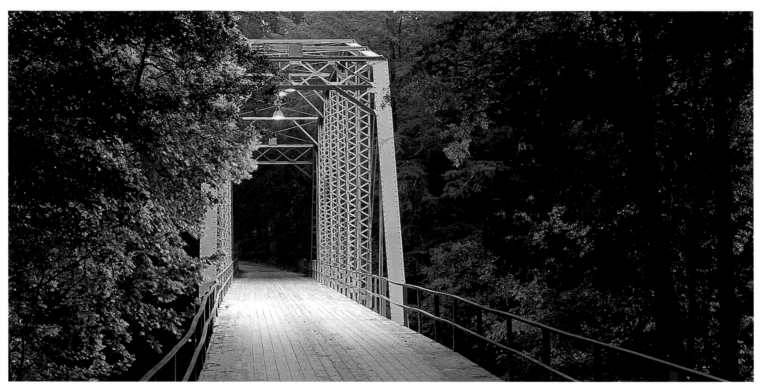

Baker County

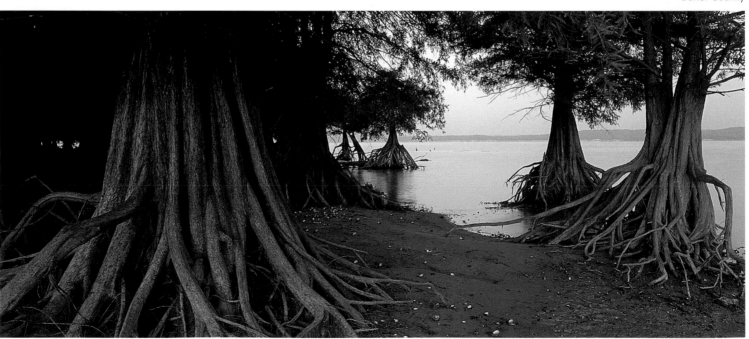

(above & facing page) Bagby State Park on Walter F. George Lake

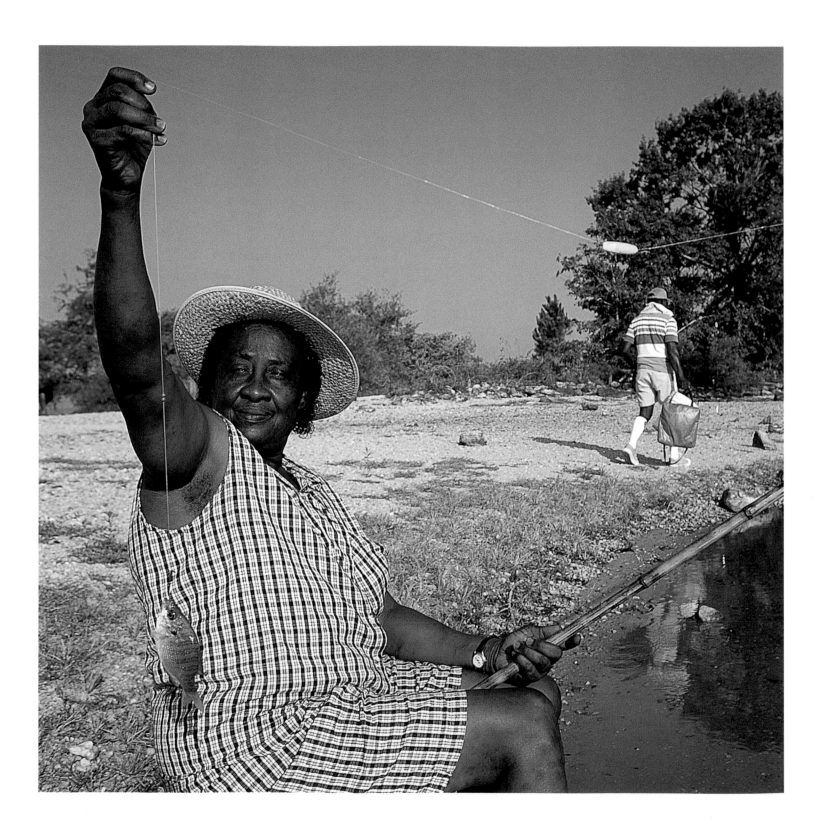

Bagby State Park on Walter F. George Lake

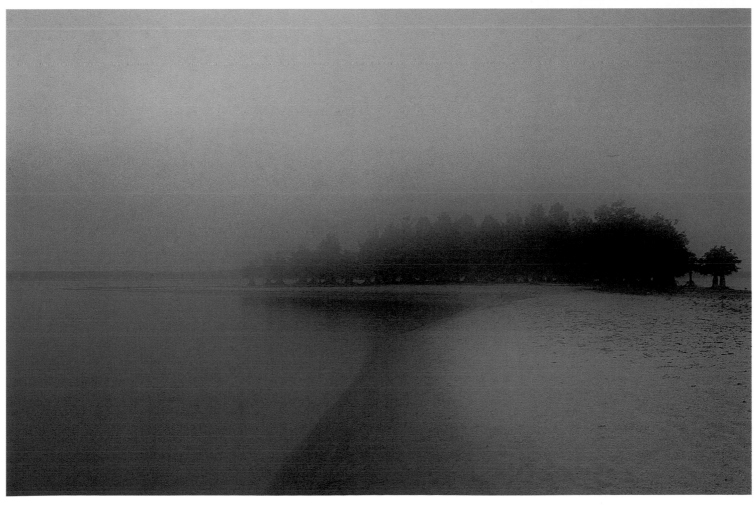

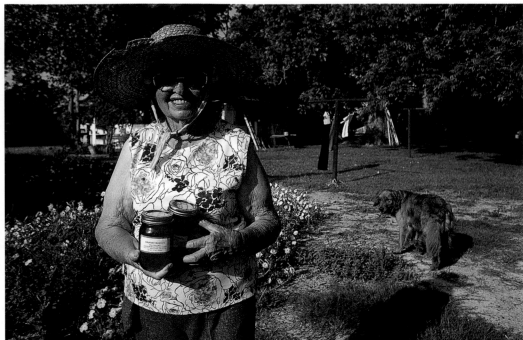

Granny Mamie Morrison of Cairo, like many other southerners, makes jelly from the fruit of the mayhaw, a small tree native to the south Georgia wetlands.

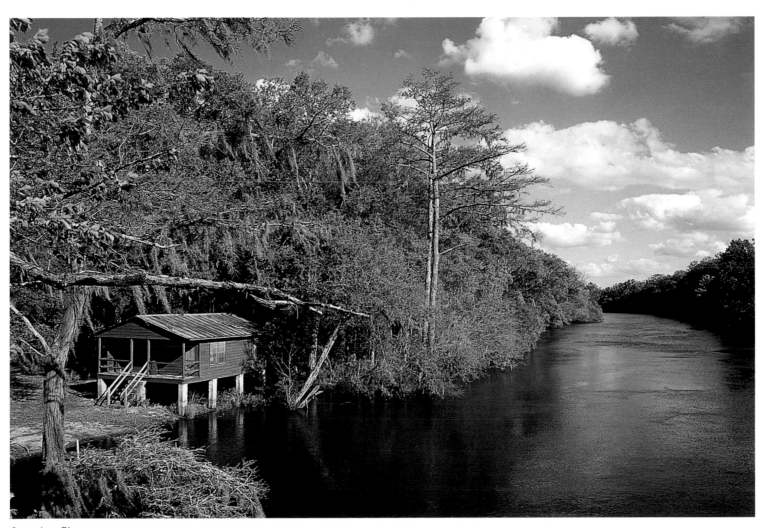

Ogeechee River

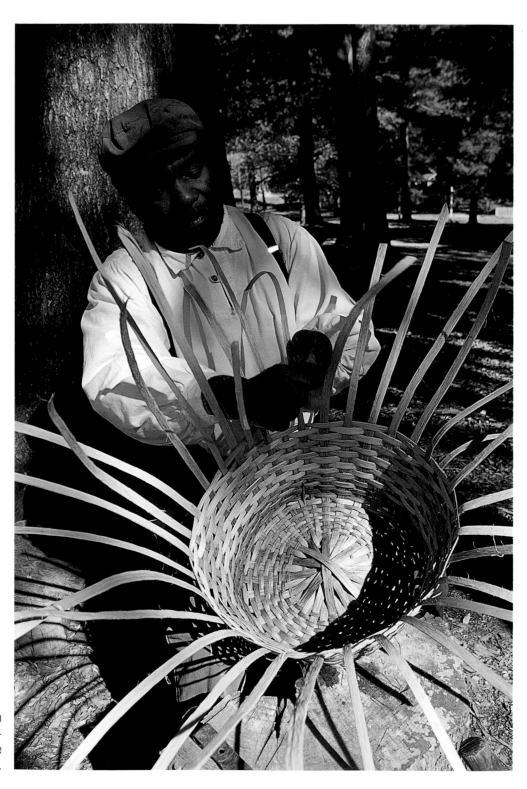

Fred Rembert weaves baskets and Stephen Hawks turns pottery in Westville's fifty-eight-acre village created to preserve the architecture and traditions of the 1850s.

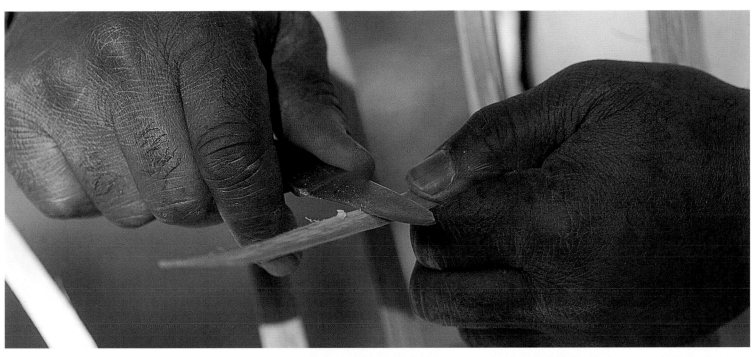

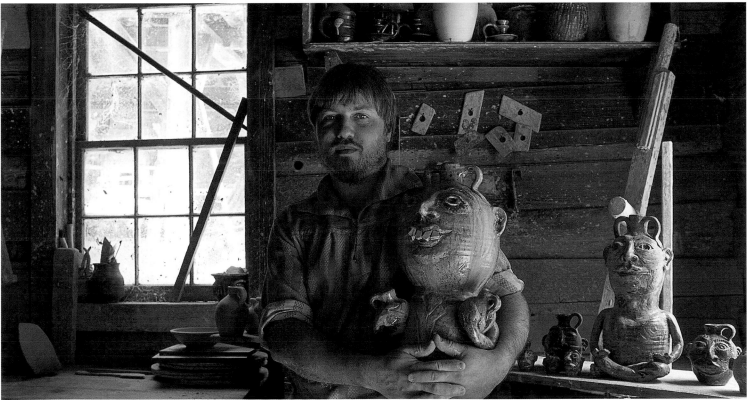

[C]

Have you admired
the great blue heron balancing on sticks among the water lilies?

She lifts a leg, turns,
 and jabs her stiletto into the clotted water.

Among the water lilies cradling their little yellow flames
the alligator admires the heron,

and from her fork
on the mossy branch, the bobcat waiting for twilight admires
the surgical movements of the heron.

To the blue heron her mission is clear.

Her life is patience and the judgment of instinct.
She senses the darting minnows,
 the submerged gator,
the power of her wings.

———

At twilight in the Okefenokee
 the bobcat sidesteps the cottonmouth,
and the cottonmouth patient in its grass-wallow
goes undisturbed.

The bobcat moves into a darkness of muskrat and marsh rabbit,
raccoon, fox squirrel, armadillo.

The bobcat is attuned to the darkness.
The cottonmouth in the marsh grass is attuned to the darkness.

The damselfly at twilight finds precisely the right perch.
The deerfly at dawn,
 precisely the right host.

———

The sun glares low over the prairie of bladderwort and water lily.
Sandhill crane and egret
 wade among the blossoms.

Two cooters on their half-sunk tree sunbathe among the water lilies,
and from her half-sunk branch,
 the anhinga fans her wings.
The copperhead slips like poured glass over the cypress root.

And you on the narrow water-trail, slapping mosquitoes
and spiderwebs, clearing
with your paddle
 the spiky brush-clogs,

to what are you ordained?

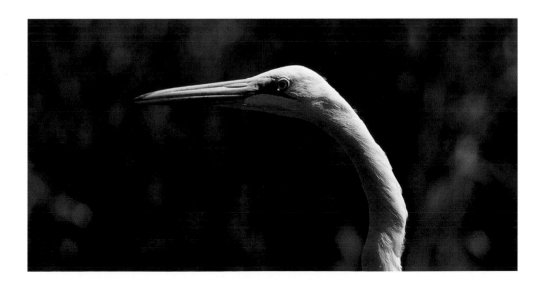

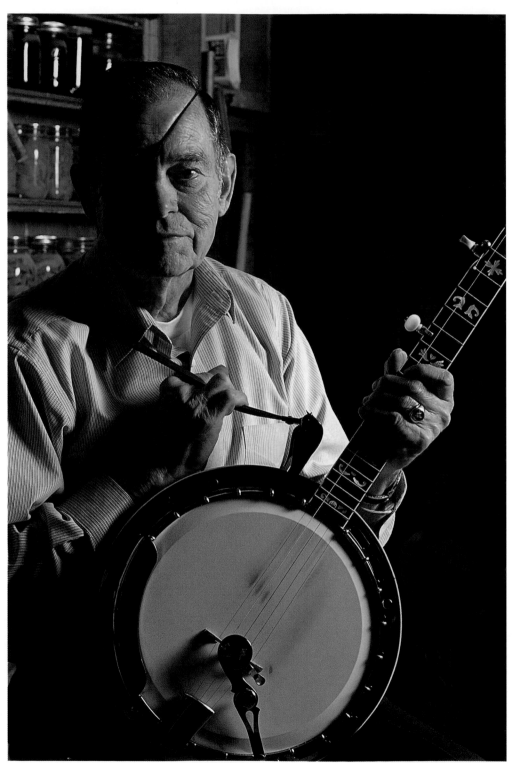

(left & facing page, above left)
Inlaid mother-of-pearl graces C. E. Pullen's handmade banjo, which he plays in his band "Pullen Grass."

(facing page, below left)
The beautifully restored Rylander Theater in Americus looks just as it did in 1921, but it now has state-of-the art theatrical equipment.

(facing page, right)
Kalcho Gadevsky, cellist with the Albany Symphony Orchestra

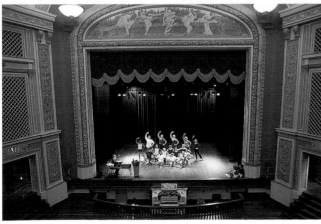

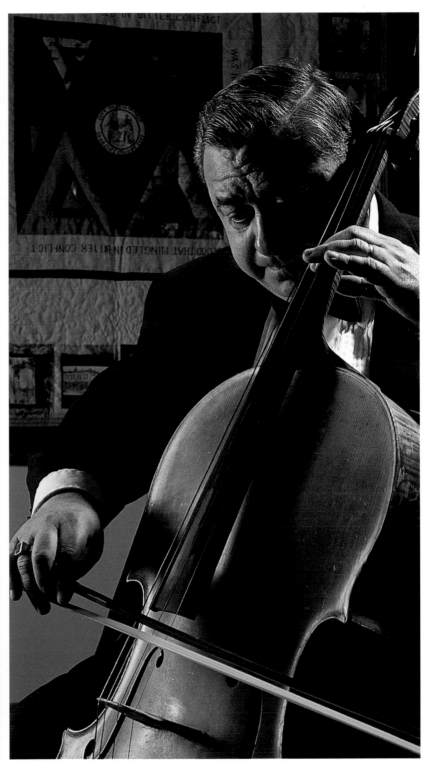

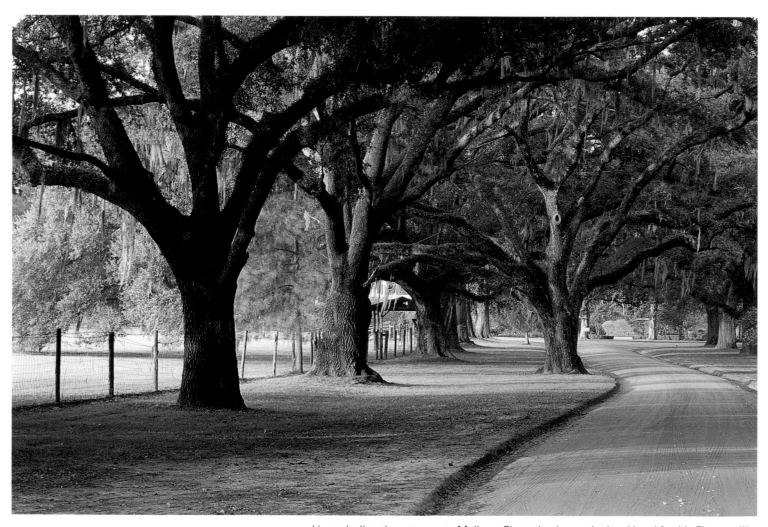

Live oaks line the entrance to Melhana Plantation (now a bed and breakfast) in Thomasville.

(facing page)
Camellias in Massee Lane Gardens, Fort Valley

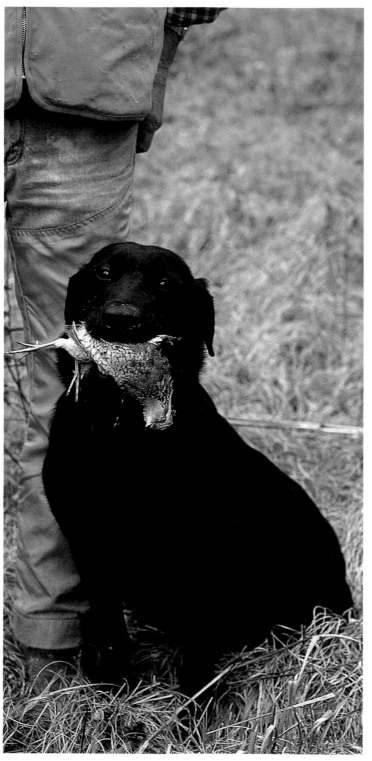

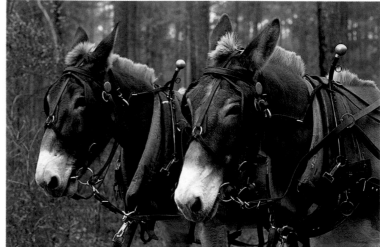

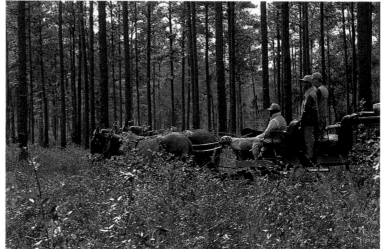

Watching the skill and dedication of a fine-tuned hunting dog from the back of a mule-drawn wagon is one of the joys of quail hunting in southwest Georgia.

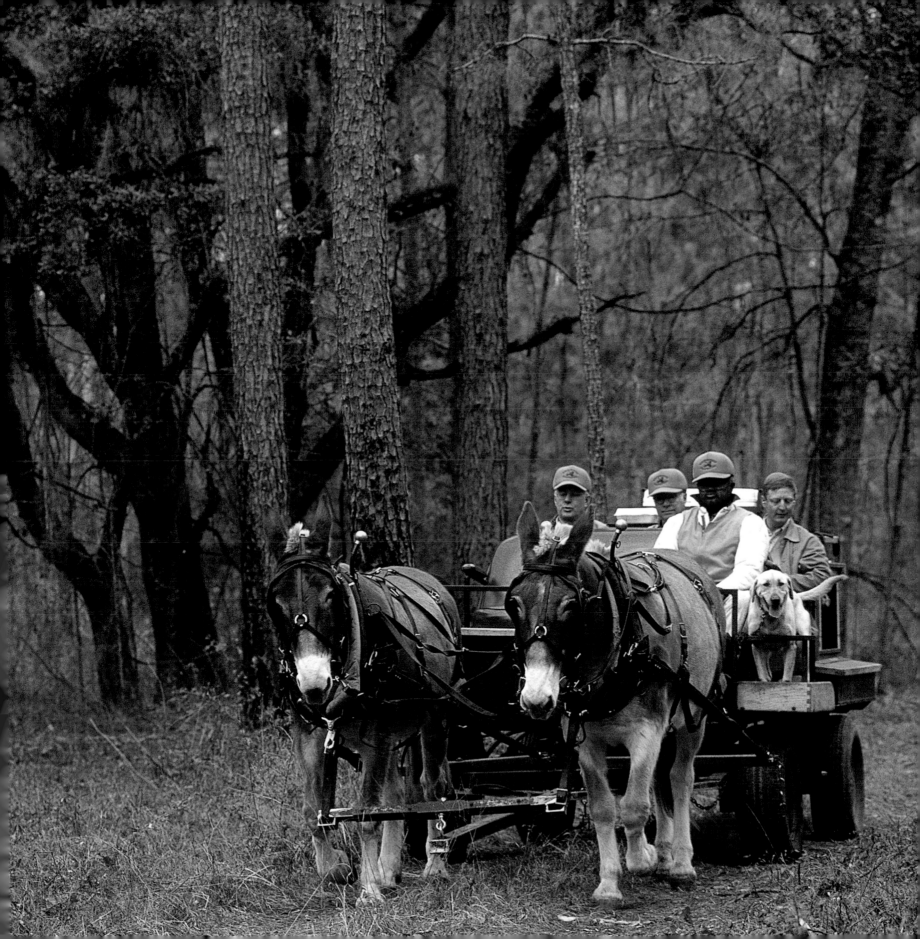

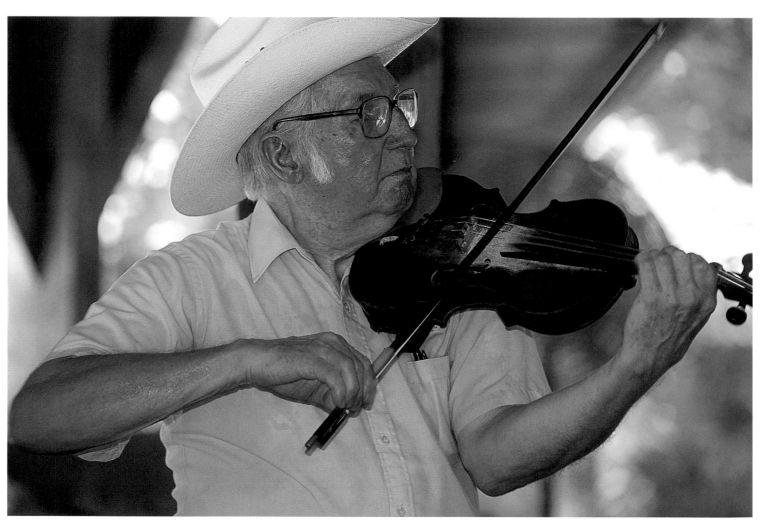

Fiddling contest in Westville

Benevolence

[D]

Do you keep your eye on the world?

The world is more than an oak leaf in mossy sunlight,
but a lot can be learned
 from a leaf in sunlight.

You must open the leaf and read your orders.

Spanish moss and peacock in Valdosta

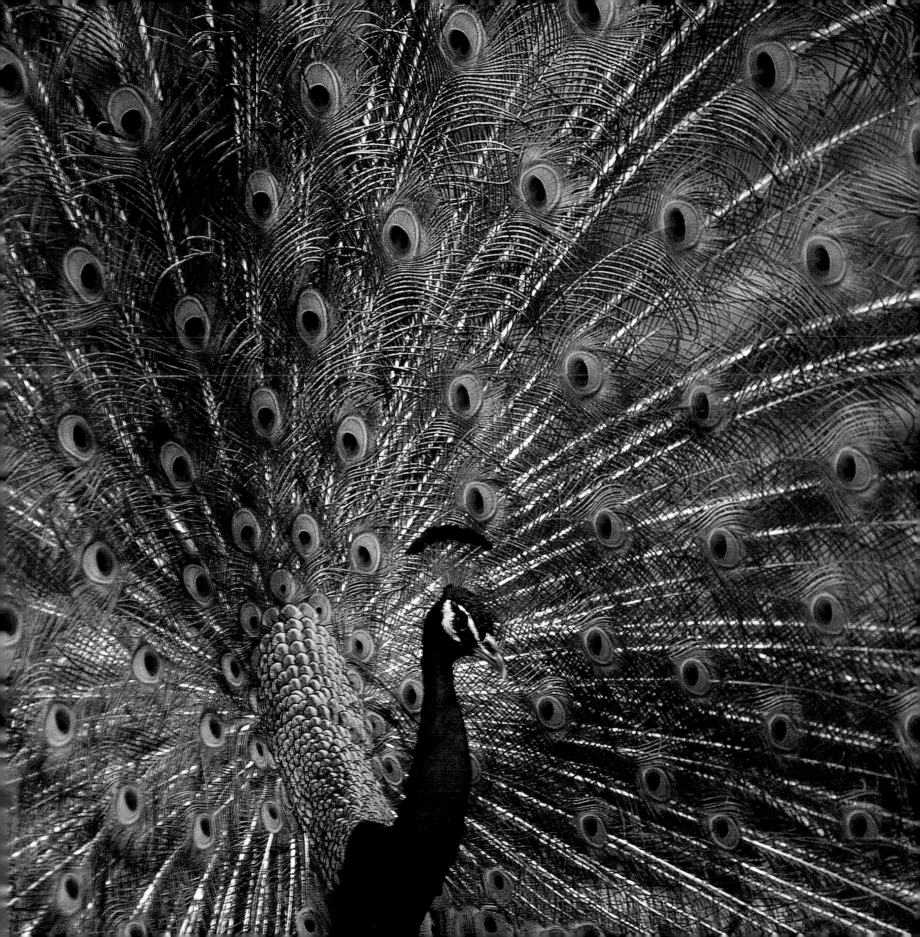

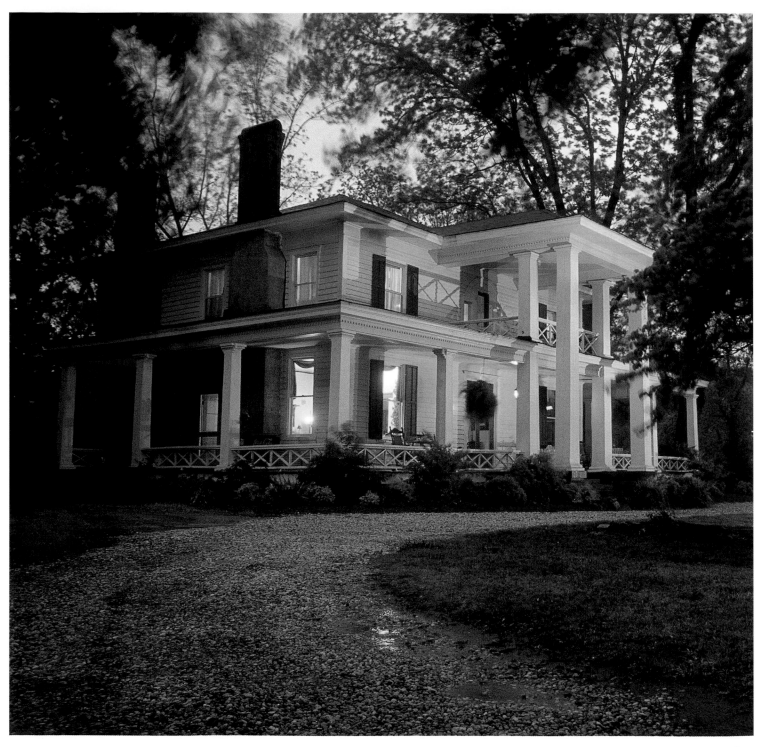

Buena Vista

Thomasville

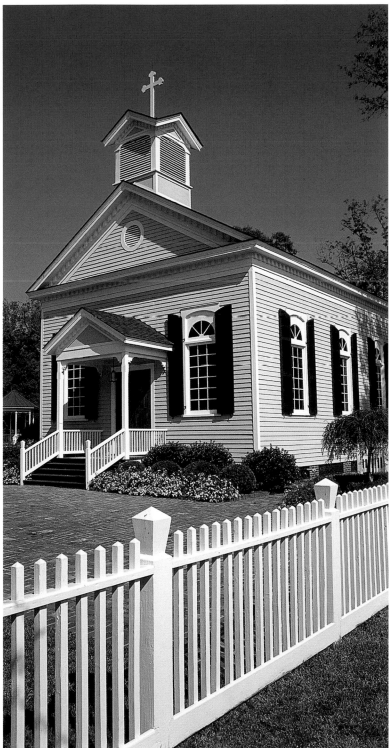

(below & facing page)
President Jimmy Carter (born and raised in nearby Plains), President Franklin D. Roosevelt, and John Dillinger are just a few of the celebrities who have stayed at Americus' Romanesque Windsor Hotel.

(above) Fitzgerald

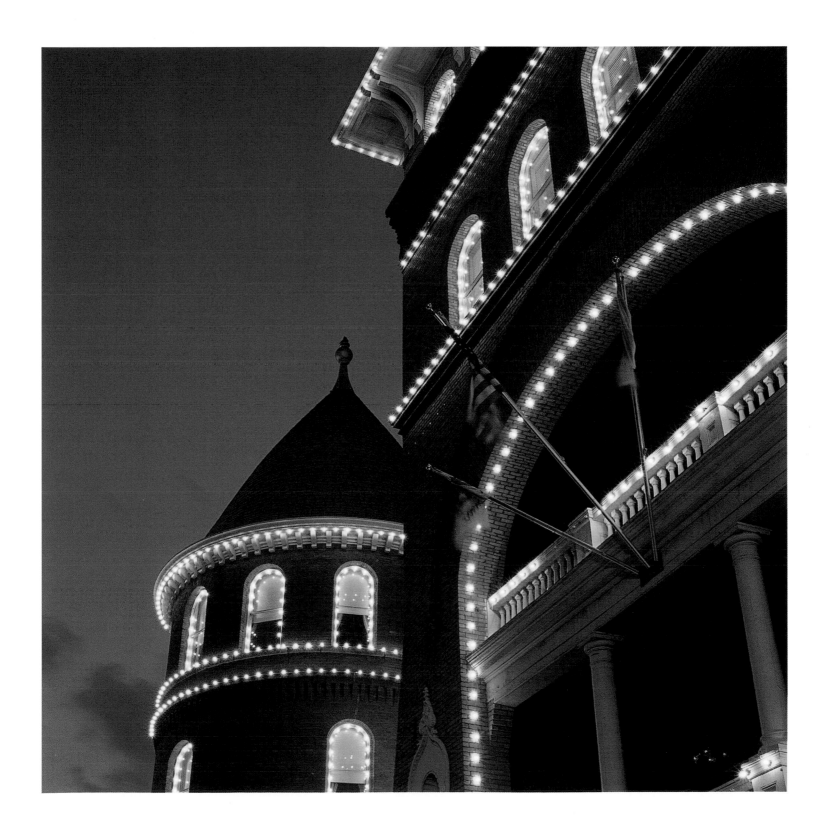

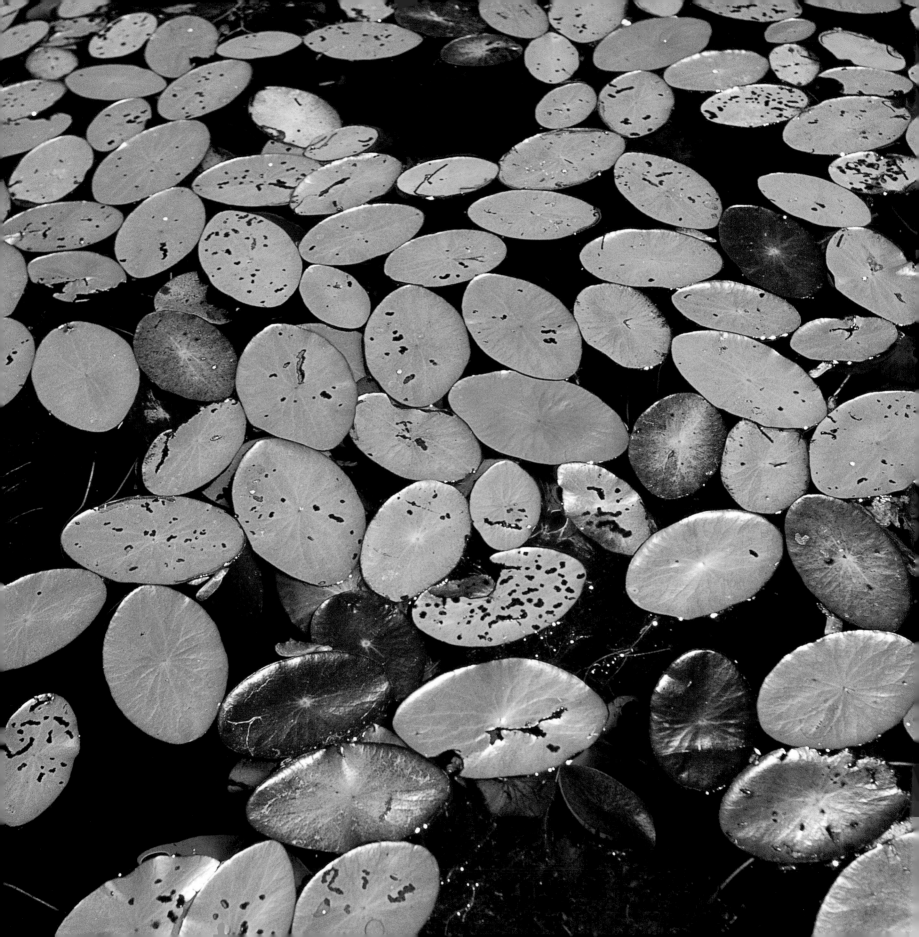

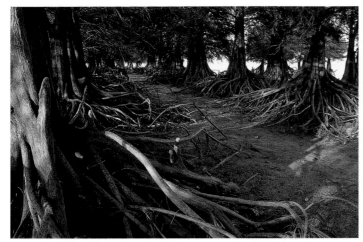

Bagby State Park in Clay County

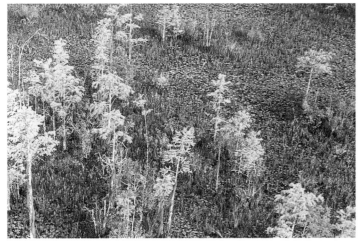

(facing page & above)
Banks Lake in Lanier County

(right)
Longleaf/wiregrass woodlands in Baker County

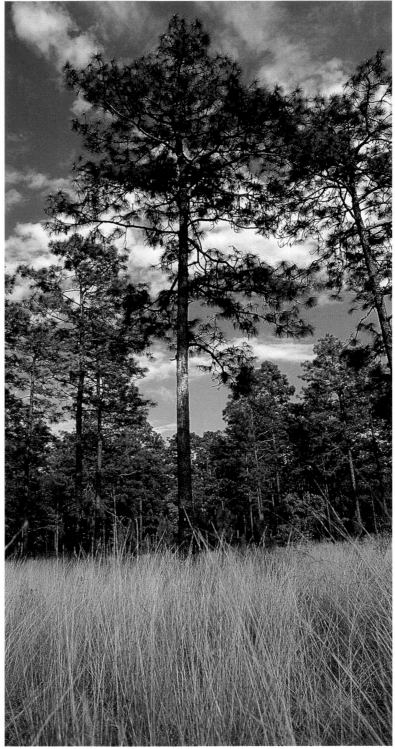

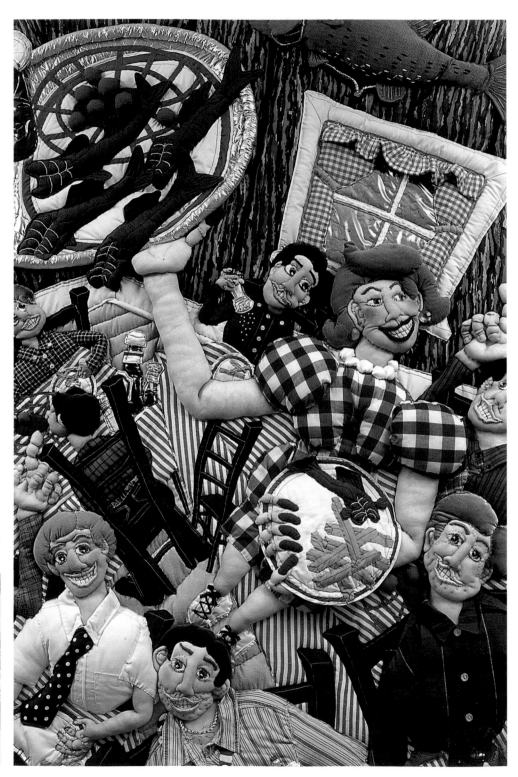

Betty Bivins Edwards' quilt sculptures capture the food rituals of the South.

Taxi drivers Mudcat and Bro Bear wait for the phone to ring in Fitzgerald.

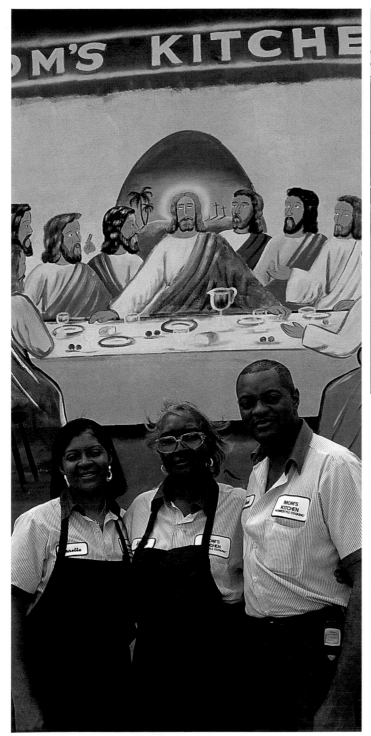

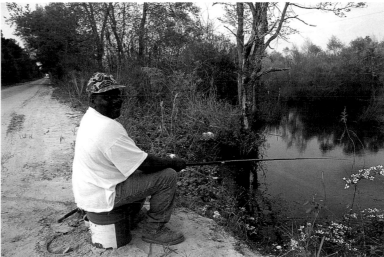

Jenkins County

Mom's Kitchen in Preston

[E]

Plains, Georgia, 1930s.
Snapping turtle big as a washtub, and gnashing at the hook . . .

A boy and his friend,
heart-crazed, drag it to the creek bank. Neither has seen such a turtle
so they tie it to a sapling
and lug it home through the swampy woods.

Rain then, or a darkening drizzle, and the soft ground
dampens to slush.
 The turtle swings between them, each boy revising
for parents and friends
his own sweet story of the catch.

Then darkness, more walking,
 and they cross their own tracks.
Now two boys lost, and feeling caught themselves,
they let the turtle go.

Now only that thought of home,
 and the nightmare unloosed
from the dream. Already their fathers are rounding up men—
trucks on the road,
 farmers with lanterns fanning the woods.

Wood stork habitat at the Harris Neck Wildlife Refuge

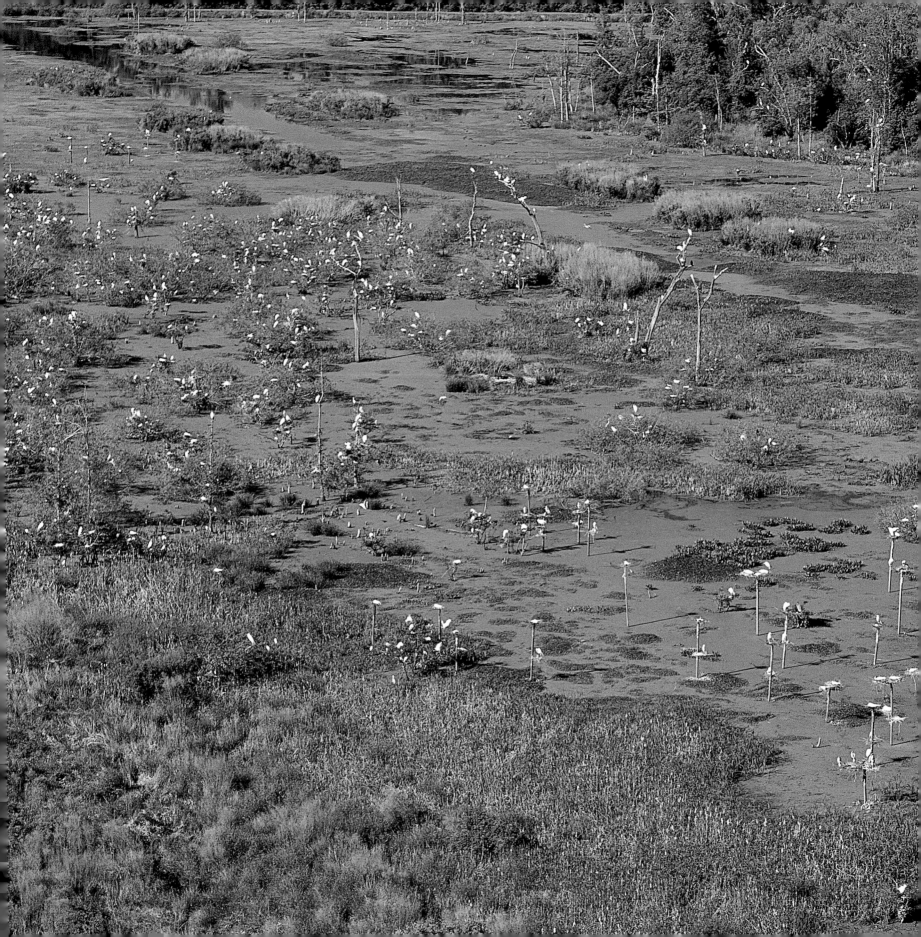

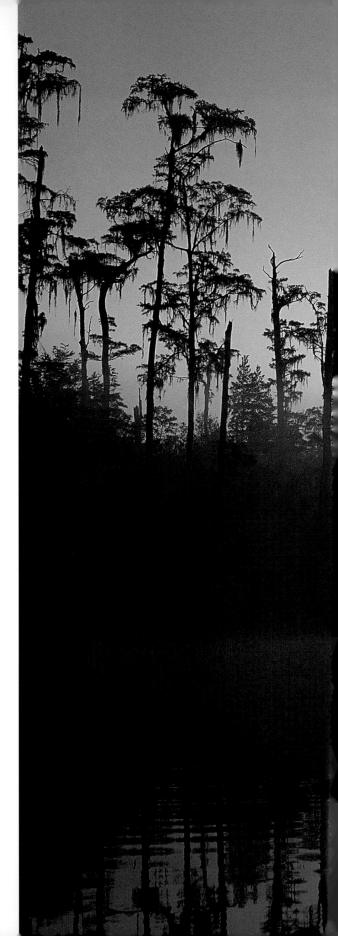

How long then before the sky clears
and one conspicuous light shimmers through the pine tops,
and a boy,

 because his father has taught him,
knows this is the evening star?

 ——

He followed a light out of the woods. He followed the evening star.

Owls in the distance
 and the coarse unnerving voices of the night—
he kept his eye on the evening star.

Into the field of a neighbor's farm,
 he followed it west.

 ——

What are you following?

He wrote,
I see the glory of God around me, in the unfathomable mysteries . . .

I think of God as an omnipotent and omniscient presence,
a spirit that permeates the universe.

Through the coarse unnerving voices of the world,
he continued to follow a light.
 What are you following?

Okefenokee National Wildlife Refuge

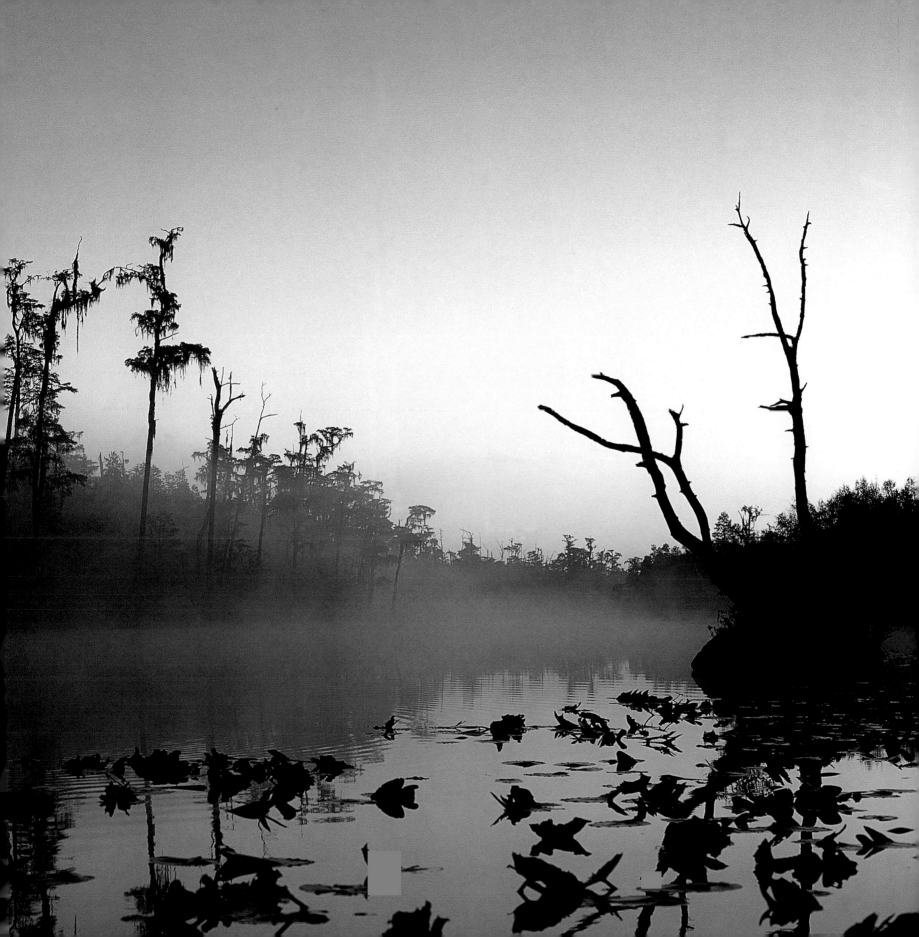

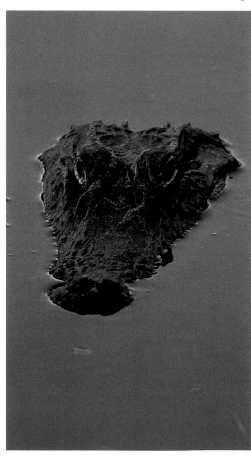

Okefenokee National Wildlife Refuge

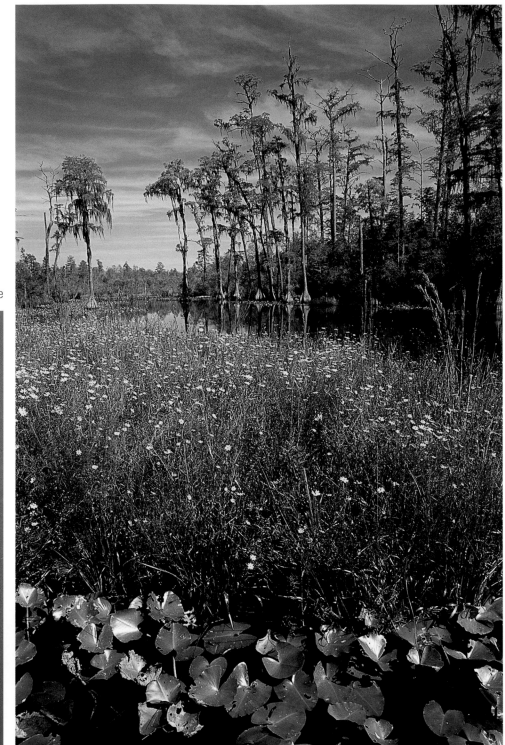

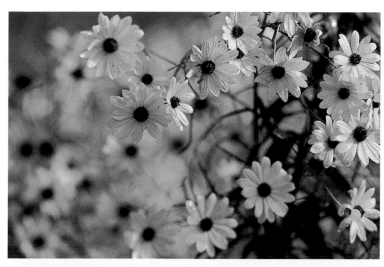

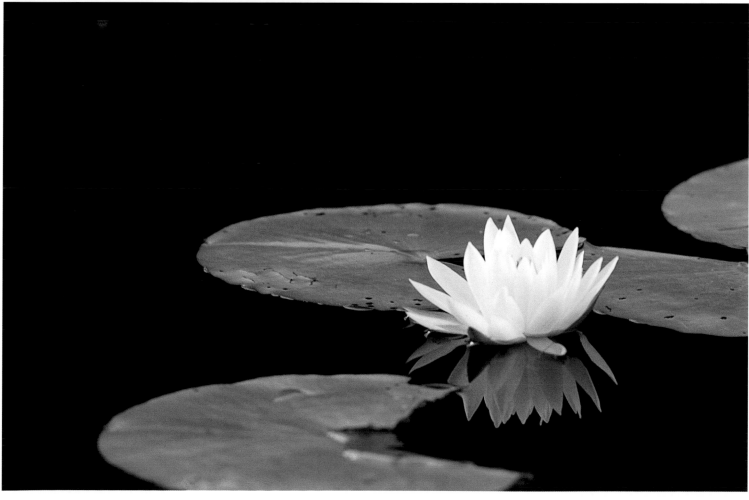

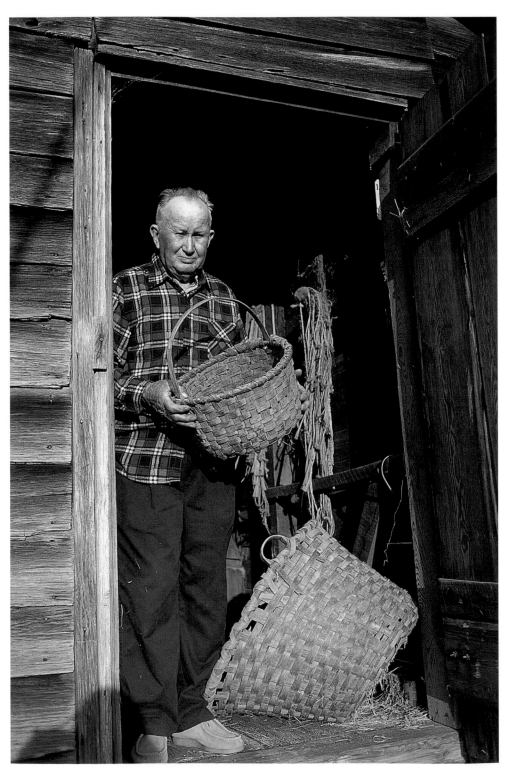

Walter Zoller on his 201-year-old family
farm in Effingham County

Liberty County

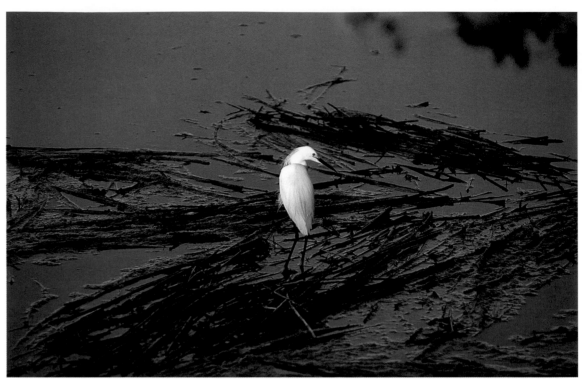

Sapelo Island

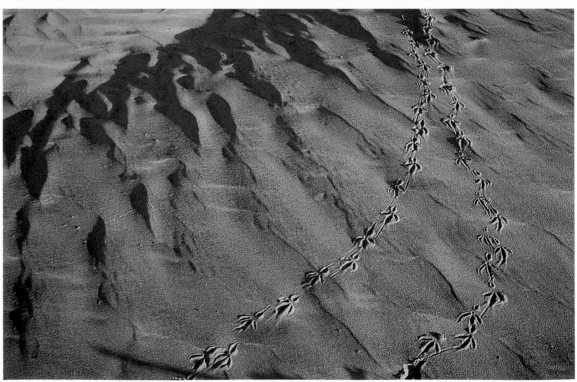

Cumberland Island

Jckyll Island

Sapelo Island

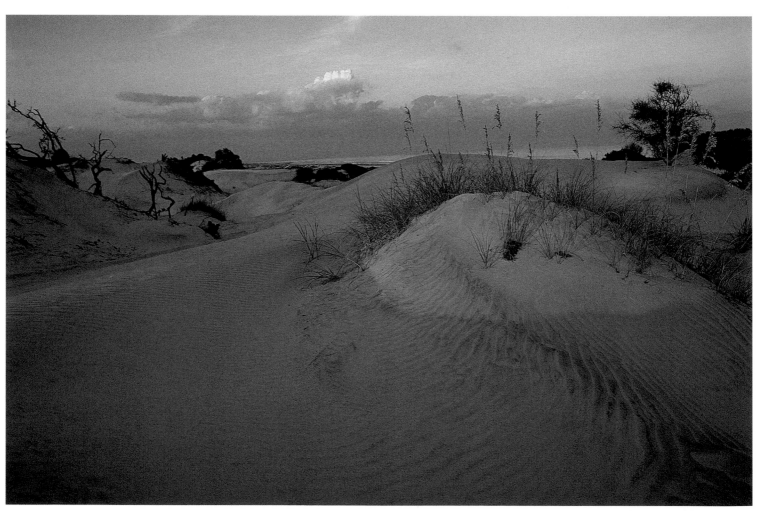

Cumberland Island

Sapelo Island

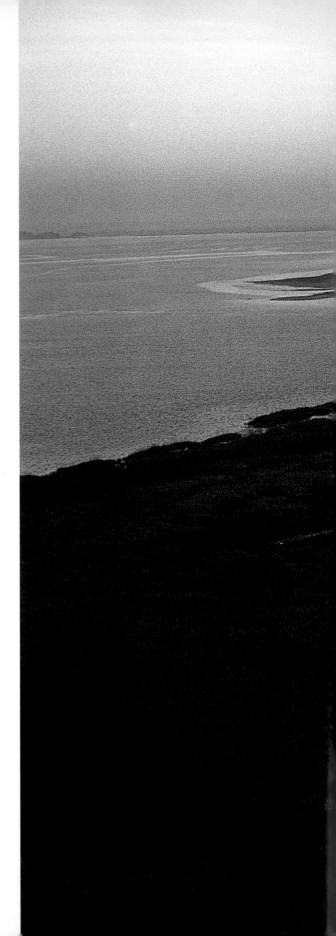

IV. Sea Island Coda

The world is struggle.
And the afterworld, perhaps, is also struggle.

But on this dune where the sea oats sway above the ocean,
there is this moment of calm.

The loose waves rake their sigh over the beach,
and the tiny shells settle again on the sand.

The sun on the horizon is a buttery fire,
and the sea oats on the dune
 are a buttery fire.

The sea oats have struggled into the ocean air.

Their mission is to stand in sunlight on the crest of this dune,
and in rain and wind
 on the crest of this dune.

Sapelo Island's lighthouse, built in 1820

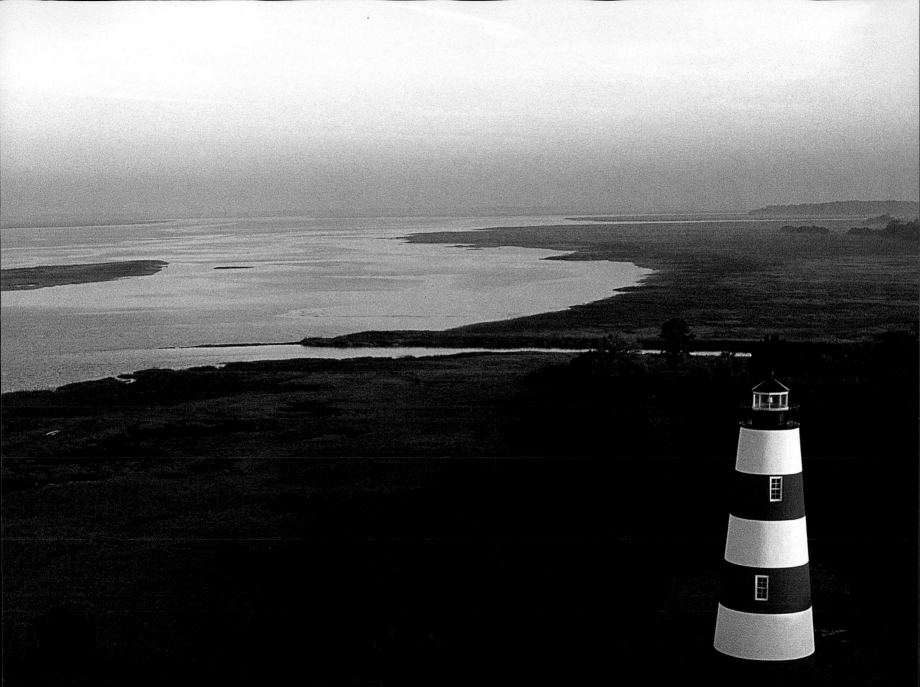

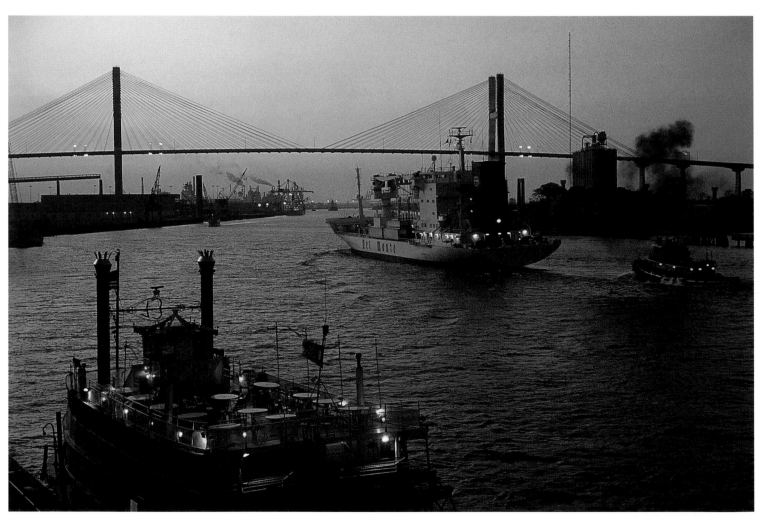

Scenes from Savannah

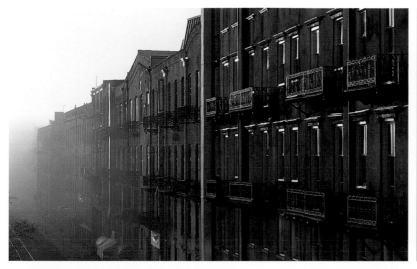

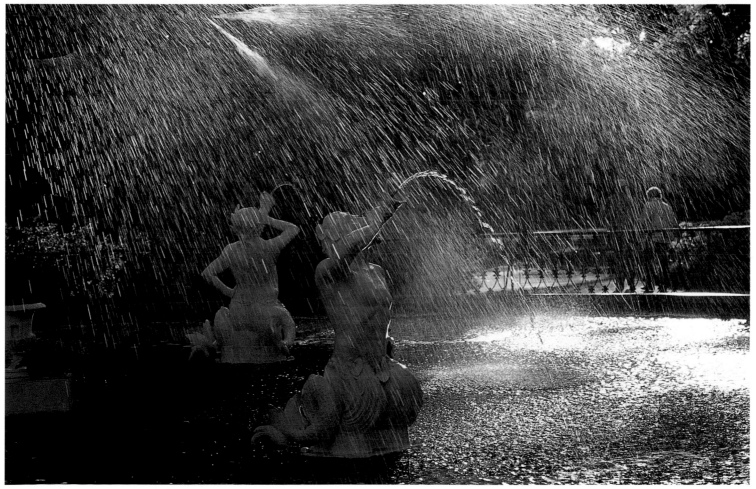

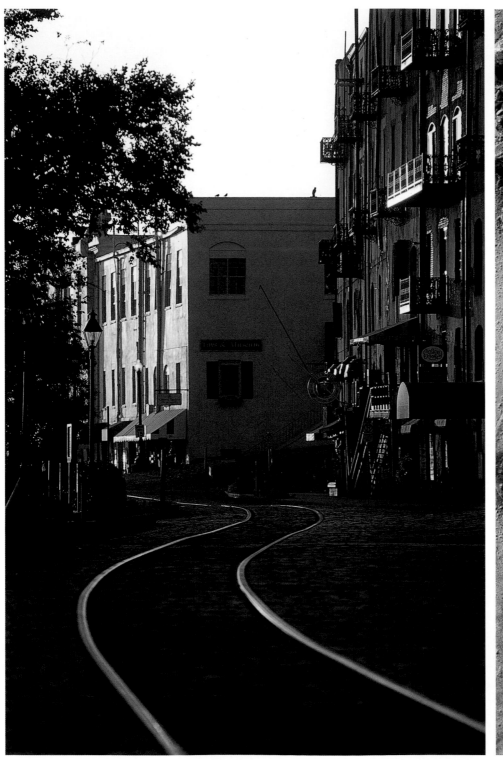

Scenes from Savannah

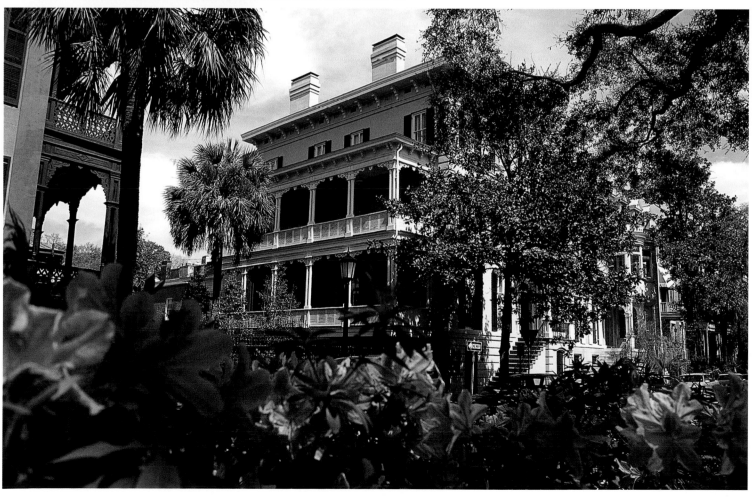

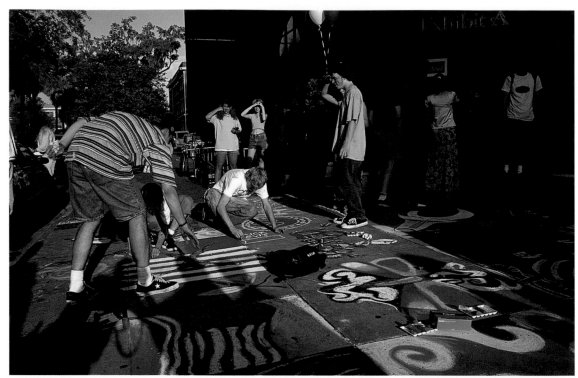

Sidewalk art at the Savannah
College of Art and Design

The Telfair Academy of
Arts and Sciences

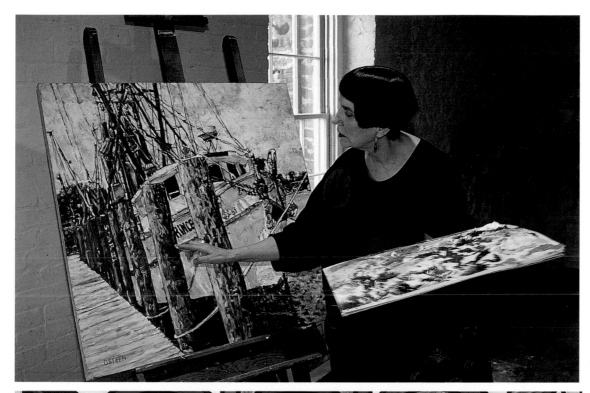

Telfair Prize winner
Ann Osteen paints shrimp
boats with her hands.

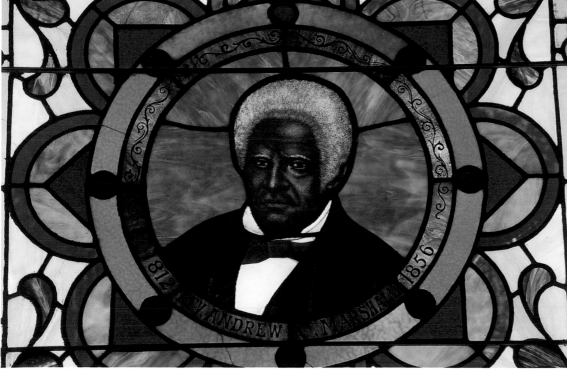

Founded in 1773, the First African
Baptist Church in Savannah is one
of the oldest black churches in
North America.

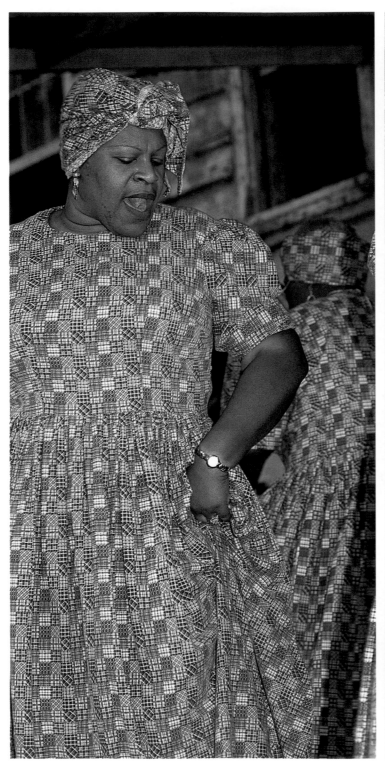

The McIntosh County Shouters, winners of the prestigious National Heritage Award, are perhaps the last practitioners of "the shout," one of the oldest surviving African American religious song and movement traditions.

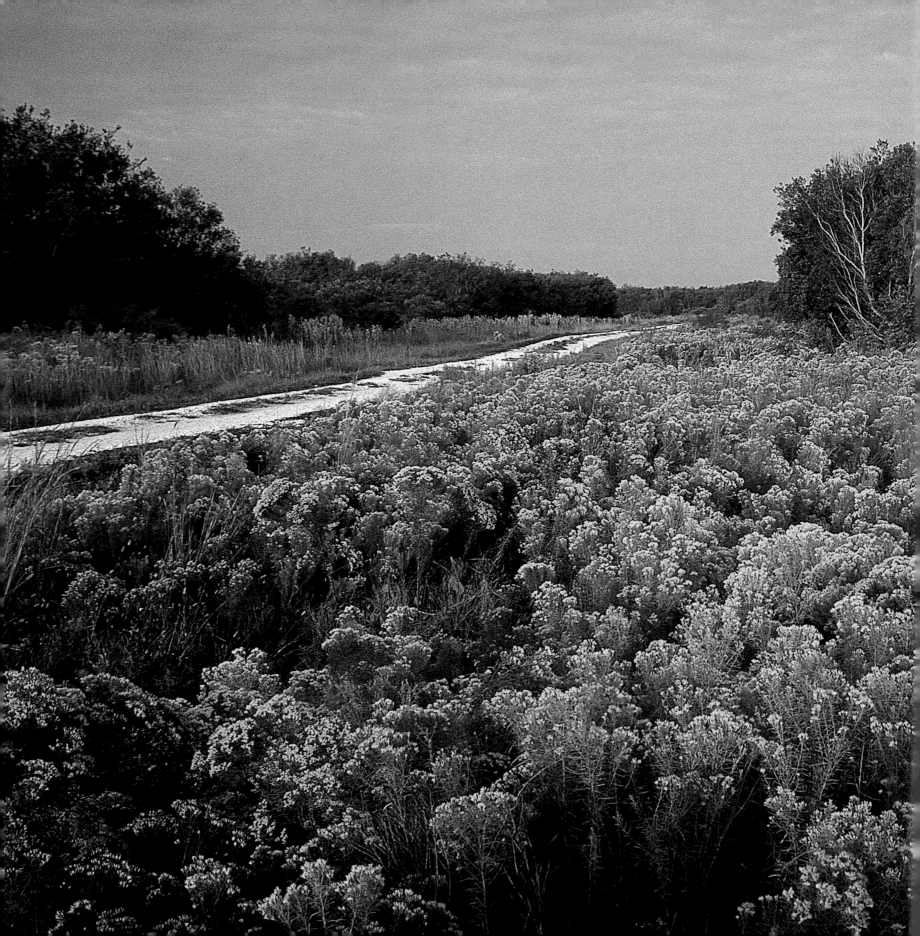

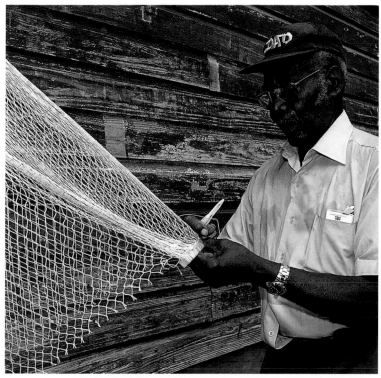

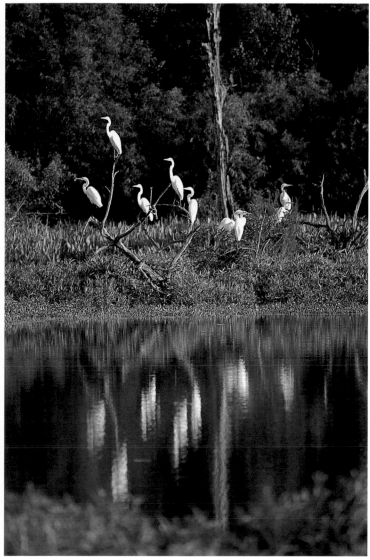

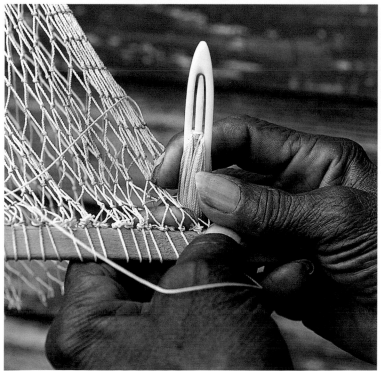

(facing page)
Little St. Simons Island

(top & bottom left)
John Stevens (Seabrook) knits a shrimp net just as his grandfather taught him. The Seabrook Village is now a living history museum dedicated to the authentic portrayal of African American history and culture on the Georgia coast.

(above)
Melon Bluff, Liberty County

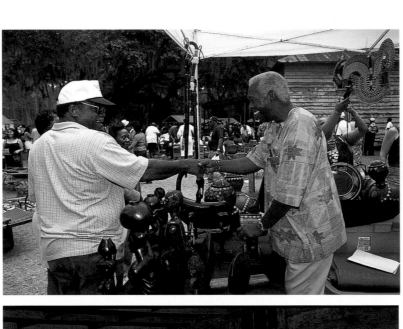

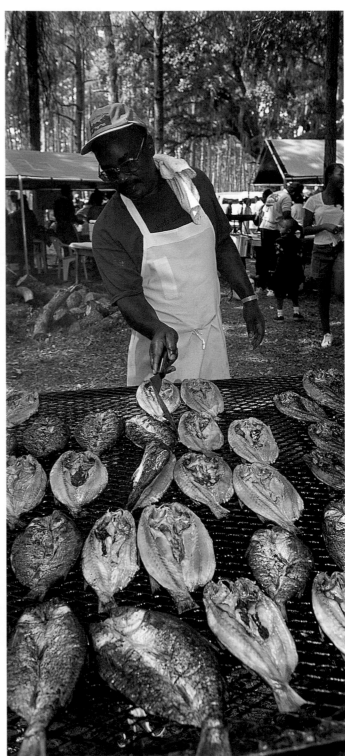

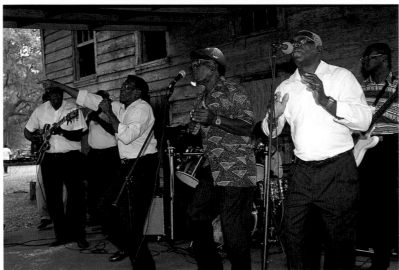

Sapelo Island Cultural Day celebrates the Gullah-Geechee traditions passed down on the barrier islands from slavery days.

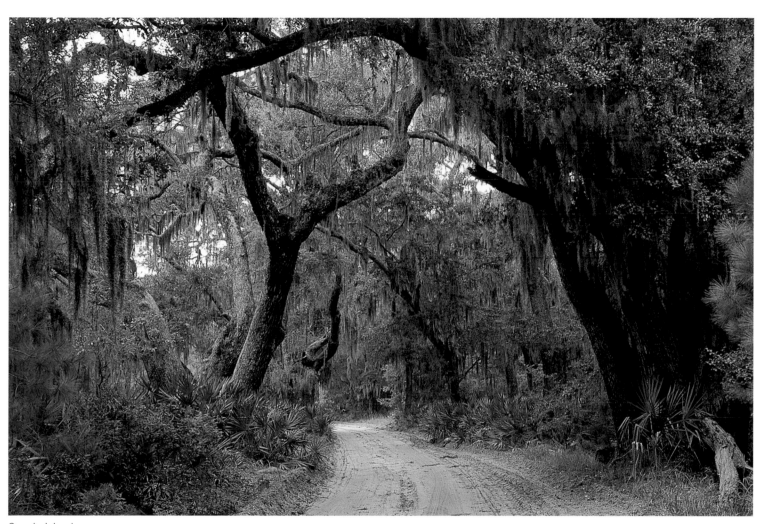

Sapelo Island

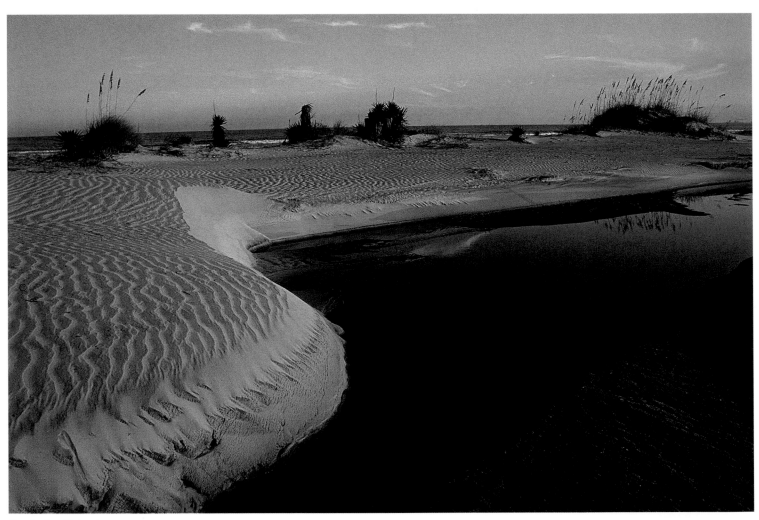

Cumberland Island

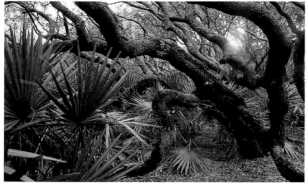
Live oaks

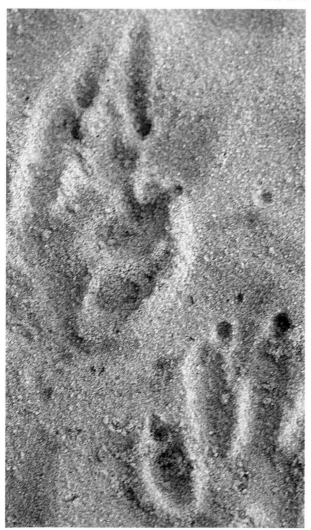
Alligator tracks

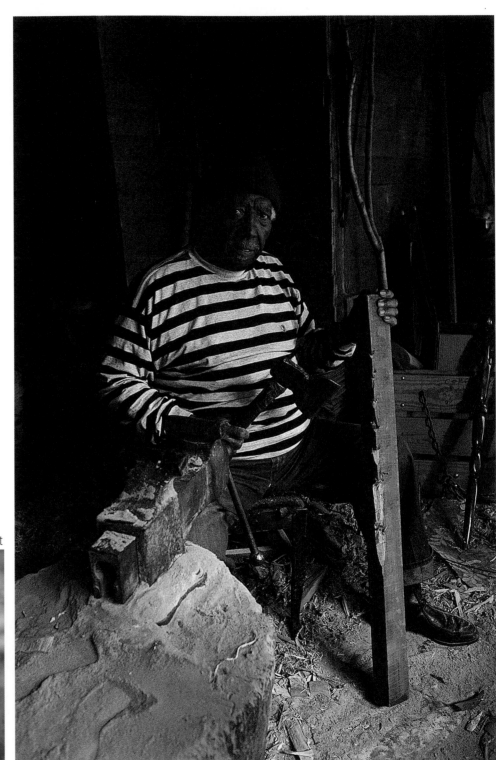

Savannah walking-stick carver Arthur Dilbert

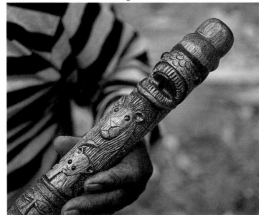

Sapelo Island

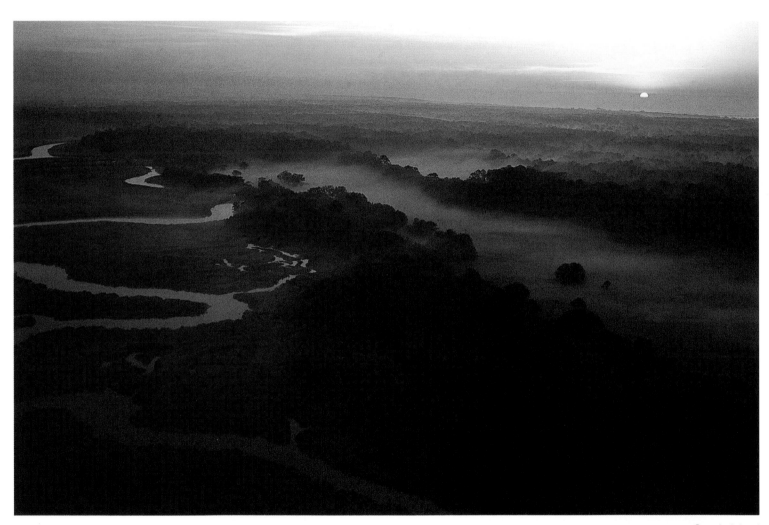

Sapelo Island